# LOOKING FOR THE SUMMER

FOR JIM AND FLORENCE VANCE

*Who shared with me the incalculable gift of support and friendship at the highest level.*
*Their loving challenge to strive for excellence is my constant companion.*

# FOREWORD

*I went to the woods because I wished to live deliberately, to front only the essential facts of life, and see if I could not learn what it had to teach, and not, when I came to die, discover that I had not lived.*

Henry David Thoreau

Thoreau taught us to appreciate each of nature's most minuscule offerings as the grandest gift of all. Through his writings we learned that our natural surroundings are bigger and more powerful than anything man could ever dream of creating. We acknowledge that it is only through a deep communion with nature that we will finally know peace. Jim Brandenburg's reverence for nature is just as humbling. As a naturalist and a photographer, he teaches us about the magic of the American northwoods. His visual poetry takes us on an inward journey as we contemplate the paradox of a nature that is sometimes gentle and kind and sometimes bitter and raw. His photographs are simple, yet complex.

Most of us see but don't look. Some of us look but don't see. Jim Brandenburg is blessed with the gift of seeing and looking at the same time. He transcends the cursory and the insightful, and joins them into one endless stream of consciousness. In so doing he allows his public to experience harmony in nature through his photographs. But he takes the challenge a step further and does this in his own backyard, the northwoods of Minnesota. His is a tender love that allows us to experience the spirit of the land within. His photographs become accessible as a lyrical work of art that becomes a vehicle for understanding nature and all that is in it.

His work, *Looking for the Summer,* is the culmination of his lifelong love affair with cool streams, shimmering stands of birch, bitter foggy mornings, scented pine forests, secretive wolves and majestic herons. He shares his world with patience and kindness, one glorious image at a time. In his current work he photographs a summer in northern

Minnesota, from the solstice to the equinox. He too wanted to emphasize the essential, and chose one emblematic photograph for every day of that magical summer. Jim takes us by the hand and allows us to sit with him on the dew-soaked moss of an aging cedar and witness the outburst of summer, its deep greens, early morning pastel blues, and browner than brown earth.

This is not just a nature book or a book of extraordinary photographs, but a journey in which we share the mood swings of a northwoods that is not only kindhearted and giving, but one that teaches us that our lives are as fragile as nature itself. In the clearing, peering through the peeling bark of those skyscraper-like northern birches, we believe time stands still and that summer will never end, but the cooing of loons announces the chill blowing in from a land even further to the north where the maples are already ember red. Summer is soon to become a mat of spent leaves floating down a rushing brook, the stillness of the sky broken by the cacophony of the coming waves of the winter migration. Jim takes to heart Thoreau's admonition: "We need the tonic of wilderness—we can never have enough of nature." As he continues to explore the spirit within a black spruce bog and ply the icy waters of the northern lakes, it is clear his quest for communion with wilderness is inexhaustible. Jim Brandenburg will never have enough of nature.

John Echave
Senior Editor
NATIONAL GEOGRAPHIC MAGAZINE

I live in the northwoods and my neighbors are the shy and restless kind. They're not particularly friendly and never seem to stay in one place for very long. This past week I was visited by a couple of the most timid. I suppose they stopped to take a look around because they assumed I wasn't home—just like some of my farm neighbors did back on the prairie where I grew up. They did leave their own kind of special message though, just to let me know they had come by.

Even though these two are not the friendliest, they are a couple of my favorites, and I know I enjoy their company a lot more than they enjoy mine. My neighbors, the gray ghost-like lynx, have cleverly avoided my gaze for almost twenty-five years.

It's mid-March now and this threatened species' mating season is at its peak. After finally coming across their sur-prisingly large, hand-sized tracks, I followed the amorous pair for an hour through eight inches of new tracking snow. Like a lot of wild cats, the lynx leads a solitary life most of the year, but it was clear by their intertwined footprints that this couple was getting along just fine. Once the mating is completed the male will disappear to leave the mother and kittens to themselves—until, of course, next year, when the singing chickadees again announce the end of winter. I thought I was close when I heard their mournful love nois-es through the cedars ahead. Crouched and hidden behind a large fallen tree, I did my best to mimic the painful cat howl with my embarrassed human voice. The woods fell silent. Many tense minutes had passed when a very terrified snowshoe hare shot past me. I knew then that a lynx would not be far behind. It was good to feel my heart pounding again, just as it did when, as a boy, I mouse-squeaked my first prairie fox in to my new camera. For one precious moment the lynx was mine.

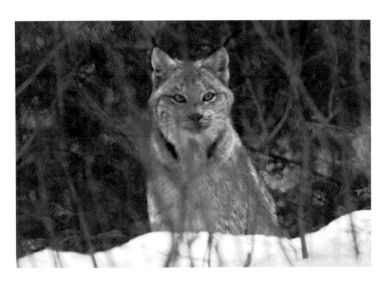

FIRST PHOTOGRAPH OF A SHY NEIGHBOR

*Canada Lynx - March 2003*

*This is a long trail on the way to introduce you to my new project,* Looking for the Summer, *but this cat-and-man story does lead me to the real reason for doing this continuation of my previous book,* Chased by the Light. *The trail will circle back, as you will see, to connect the beginning to the end. Life, for good or bad, usually follows a path that echos the universe as a circular pattern. This story is but a small circle inside that much larger and endless loop.*

*First, a word of explanation.* Chased by the Light *was a unique project, one that came at a time in my life when I had become all but reclusive. I loved my new, quiet existence in the wild northwoods of Minnesota and began to shy away from the life of a globe-trotting National Geographic photographer. In a way, I was bored of my craft, tired of churning out endless rolls of photographs in exotic locations, only to have the best cherry-picked and the rest banished to a dark corner. I needed to get back to my art, back to my home, and if you've read that book, you know that it was a personal struggle, a project designed to restore my soul. It was never intended to become a book, but fate had its way.*

*That book was unusual because in an effort to recapture my craft, I forced myself to reduce my art to its simplest, and yet most difficult, elements. For three months, from the autumnal equinox to the winter solstice, I would shoot but one photograph per day. One frame, no more, no less. If Japanese haiku is the bare bones of poetry, then that exercise would be haiku on film.*

*There were times during those months when I grew frustrated with what I was doing, for it very nearly brought me to tears on several occasions. But I persisted, and the results, though not my best photographic effort, touched many that I showed them to, so much so that I was encouraged to make this private work public. That the resulting book,* Chased by the Light, *was so well received both stunned and pleased me. Somehow, people connected to the strict regimen I had set for myself. The therapy couch became a stage.*

Considering that the project was never meant for publication, yet has become perhaps the best known of my work, you might think it foolish to attempt a sequel. Perhaps it is, but I've never been known for taking the easy path.

This book you are now holding, though, is really a different sort of endeavor. First, I did not shoot but one frame per day. I shot many. The intent was not to copy myself, nor repeat a task that, though necessary to me at the time, was artistically constraining. With this book I wanted to explore a different level of expression—not a process-driven forced march designed to wring the poison from my spirit—but instead, a simple and joyful celebration of nature photography.

In Chased by the Light I was driven in and out of dark emotional places to recapture what I had thought was lost in my art and a small but important part of my life—an intimate and long-lasting relationship with land. Not land in distant and exotic countries that were exhilarating to photograph, but land on which I could get old and die. Pursued by the light,

I gave myself over to it, and it helped me find my way. The irritating and relentless light in the rearview mirror became an illuminating pathfinder in front of me. I gladly followed.

Looking for the Summer is a brighter book, a happier book, a book that explores light and nature in the height of the exploding but brief growing season here in the north. Similarly, this book follows a three-month time frame as did Chased by the Light, starting with the year's longest day at the summer solstice and ending with the autumnal equinox. These are the ancient calendar points that our ancestors etched upon the land with alignment stones. I wasn't so much searching for myself, but for the joy and beauty that nature gives us all. I hope I found it, but you will be the judge.

I needed to search out the beauty because of a catastrophic event that happened in my part of the world. Hundreds of thousands of acres of forest were flattened around my home by a devastating windstorm. It was as if the trees—40 million—were strode upon by great beasts. It

*humbled me and depressed me, for many of the beautiful places I loved—and scenes depicted in the book—were gone. It was truly strange to be responding to people who contacted me about* Chased by the Light, *knowing that the photographs that moved them were of places that, in many instances, no longer existed in that form.*

*Some of the following words are borrowed from the revised softcover edition of* Chased by the Light. *Little did I know while crafting the words for that revision how well they would describe the inspiration for this collection. The circle is at work.*

*"I suppose it is the fault of all of us that we assume that nature cares what we think, that it evolves and acts in manners pleasing to us, since it so often does. But then something frightening and awful to behold–a flood, a tornado, or as in my case, a massive windstorm–comes and changes not only our human landscape of easily rebuildable homes or other buildings, but the very face of the earth and the places we've come to love. My passion, my main focus of my work, has been to paint nature's beauty on film. But what, I thought, is beautiful of wind-ripped trees? Of twisted trunks? Immediately after the storm I began to shoot photographs of its impact. But I shot barely a half dozen rolls of film before, disheartened, I put the cameras down. I felt robbed.*

*Since then, I have spent much time thinking about this "thievery." I've concluded that one can only be robbed if one owns that which is taken…*

*…The day will come—long after I am gone—when…the little island on Moose Lake will one day again grow trees. It will not be the same as I recall…but because we have set this land aside to remain undeveloped, it should nonetheless be beautiful. The art that I sought to create will be created then by someone not yet alive. Loons, I hope, will still find it a good place to nest, and downy gray chicks will once again grow to become yodeling adults within sight of the island.*

barn's burnt down…now i can see the moon.

*That simple bit of Zen wisdom from old Japan says to me that when faced with forces beyond our control we are sometimes rewarded with pleasant events, though equally unexpected. I have cleared away thousands of downed trees near my home so that it is safer from the inevitable dry-year fires. Now the earth is open to the sun, and vistas I never imagined greet me from my door. A young forest is already sprouting, trees that perhaps will grow even larger and more magnificent than those they replace, trees that might not have even succeeded at all had not the canopy been opened so that they could be nourished by the light."*

*So, too, the other storm—the tempest in my life caused by Chased by the Light—also "burned down the barn." The moon that I see is a new moon. Like the windstorm, this personal gale swept away an old layer and prepared my soil for fresh growth.*

*"As one must embrace the full range of nature's power, so too must one embrace the energies of our own lives. We can pretend neither exists. We can try to stifle the fires of both or merely let them smolder. Yet in the end, neither will be denied. In the short term, the confusion may be discomforting. If we have the patience, however, to look beyond the changes, if we have the humility to realize that still there are events beyond our control, we might just act wisely.*

*For when the winds of change come, we can be among the trees that snap. Or we can be the growth that sprouts beneath the sun."*

*Ah, the wind! It blows us all. We think we know where our lives are heading, have established goals and priorities, and then a wind comes, and we find ourselves driven in a new direction.*

*That, really, was the genesis of this book. Chased by the Light set the stage. Through it, I had recaptured my art, but after it, was shocked by the windstorm's results. Only then did I see*

*the wisdom of my own advice; just as the earth was once again bathed in light now that the old trees were gone, and new things were sprouting all about me, I saw that I could again grow, that there was new, fertile soil beneath my feet. I would now set out looking for the summer in all its glory.*

*Buffalo in the northwoods?*

*No. But you'll see a bison in this book, nonetheless. In fact, you'll see several prairie images.*

*This book is a celebration of one summer, and it cannot be summer without a visit to my beloved prairie from which I grew. Though I am now a creature of the northwoods, my roots still probe the deep prairie soil. So much so that I formed the Brandenburg Prairie Foundation, through which all the profits from my second gallery in Luverne, Minnesota are funneled to prairie restoration and education. To date, as proud partners with the U.S. Fish and Wildlife Service, we've managed to acquire and restore over 800 acres of contiguous virgin grassland which we've named Touch the Sky Prairie National Wildlife Refuge. From this high, windswept, boulder-strewn ridge I can look down upon the little farm where I was born—just one mile to the east. This backyard pasture wilderness of my youth was the first ground in which I felt the "rapture."*

*The prairie nurtured my boyhood soul. I probed its few remaining wild acres amidst a sea of corn. Had it not been for that prairie, and the wildlife that remained, I could not, nor would not, have become what I am. Now, just as the prairie nurtured me, my photography—through the sales of my work—can nurture it.*

*Like all things in nature, there really is no beginning or end. A tree, whose life began when a bird dropped a seed, topples to the ground and becomes soil, which awaits another seed so that it may become a tree again. And so my career, which began with a simple plastic camera and an austere prairie landscape, also is circular. The vast sky, grass and the creatures that I clumsily put on film gave birth to my art. My art, now, can give birth back to the prairie.*

*And what of my shy neighbors, the lynx?*

*They came because a new forest grows, a young forest in which the snowshoe hare thrives. Just as the hares must have supple young trees to eat, the lynx must have the hares. And so the wind, which uprooted so many trees, by its action allowed in the light. Now the animals that do best in that environment follow behind.*

*Which is so very ironic. I have traveled widely and long sought the lynx, and in their shyness and rarity they have eluded me. But now they are in my back yard. I hear them mate, see their large tracks. They are creatures of winter and of deep snow.*

*Chased was a book of autumn. Looking is a book of summer. There will, I'm sure, come a time for a book of winter and then perhaps one of spring to round out the year. And in this continuing venture, my shy neighbors may be revealed, and I will be a partner in another loop.*

*The year, the decades, the centuries, are a circle. Ever repeating, yet ever new. I looked for the summer, and there it was, lush, gorgeous and full of renewal.*

*In many ways I feel now as I felt as a daydreaming, wind-blown prairie kid—excited by the fullness of life, eager for more, ready to follow mysterious tracks wherever they might lead me.*

*Looking for the Summer is but a part of that journey. I was not chased by the light this time. I was awash in it. The storm that ripped through my woods and life also let the summer sun shine in.*

*New life now springs forth, both for the forest and for me.*

# LOOKING FOR THE SUMMER

### THE PHOTOGRAPHS

june t w e n t y - o n e DAY 1

9:52 am

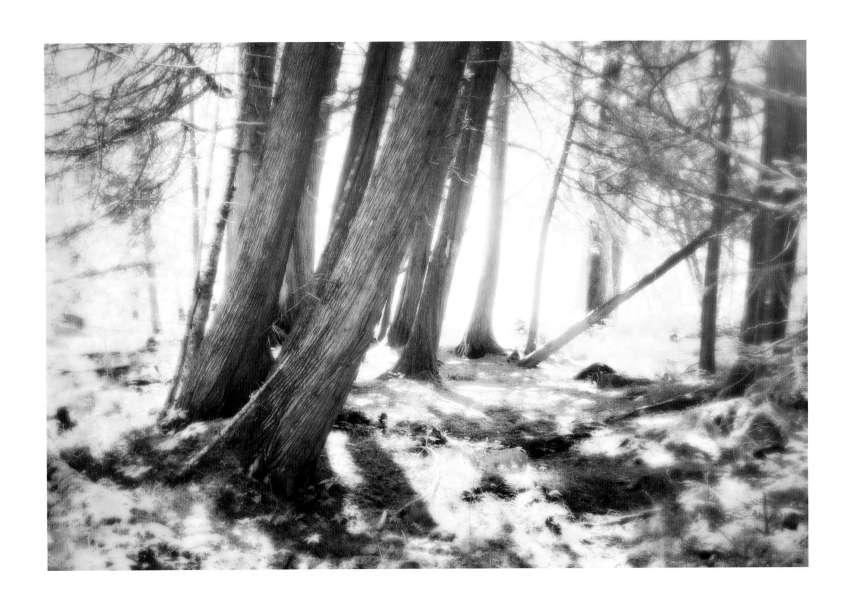

june twenty-two DAY 2

8:04 am

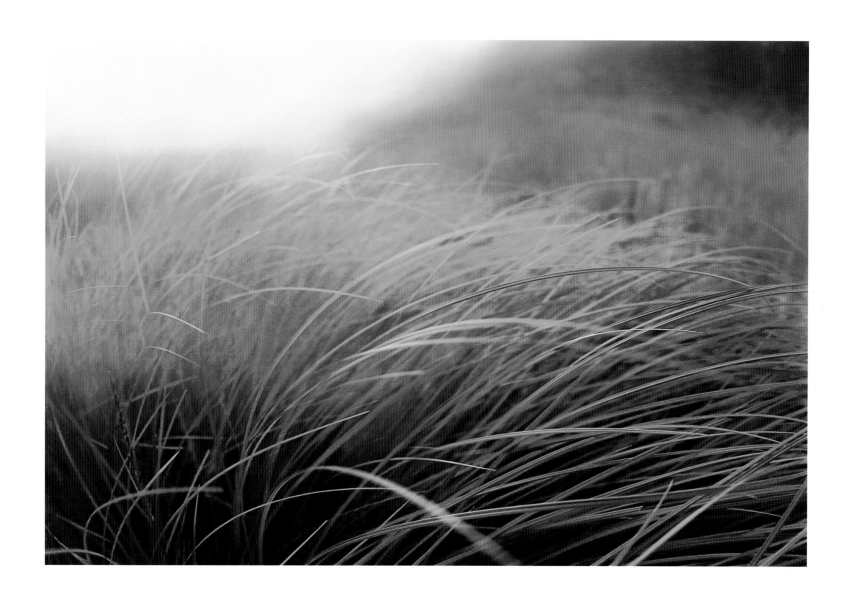

june twenty-three DAY 3

9 : 05 pm

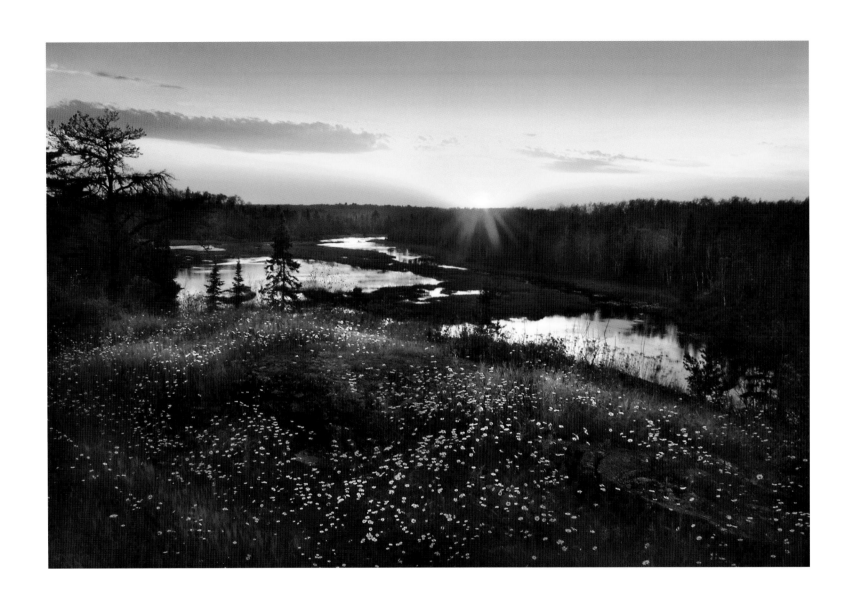

june twenty-four DAY 4

9:04 pm

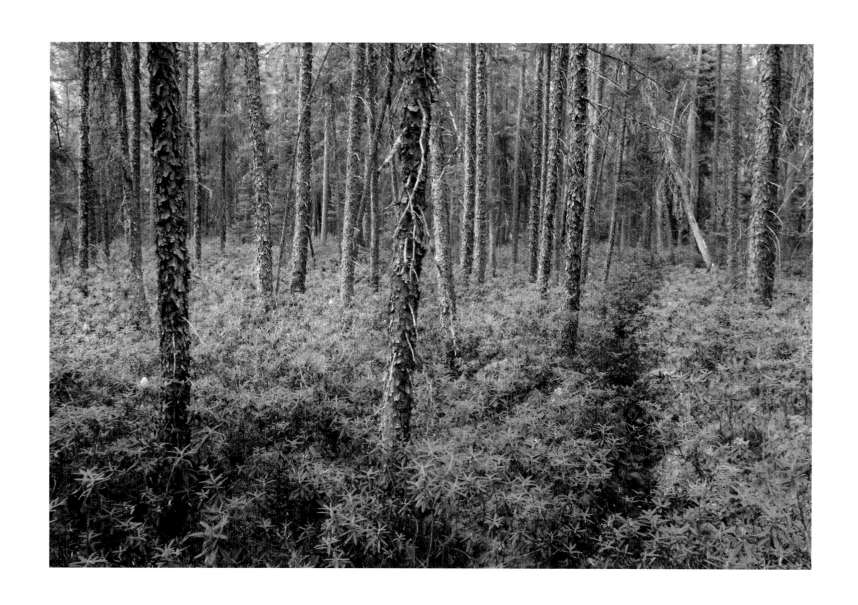

j u n e   DAY 5 - f i v e

8 : 5 8   p m

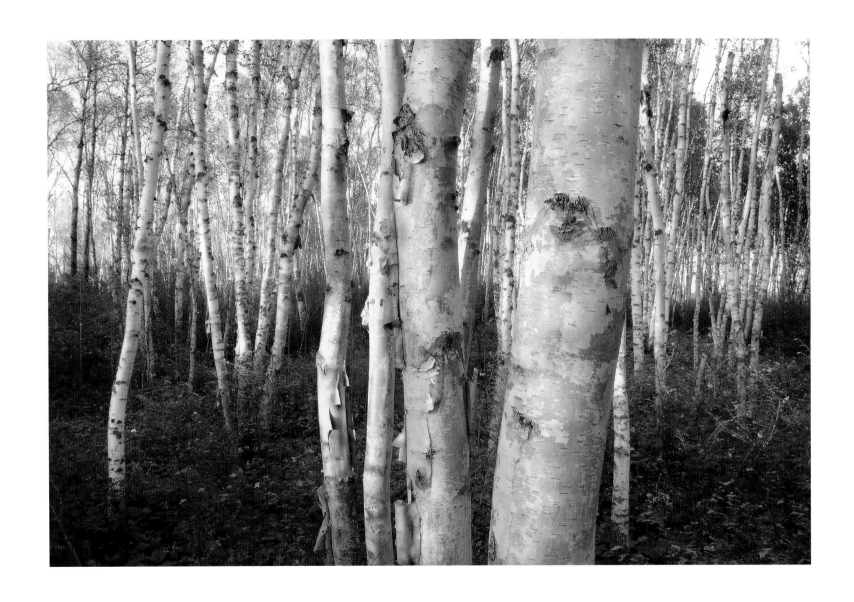

june twenty-six

8 : 26 pm

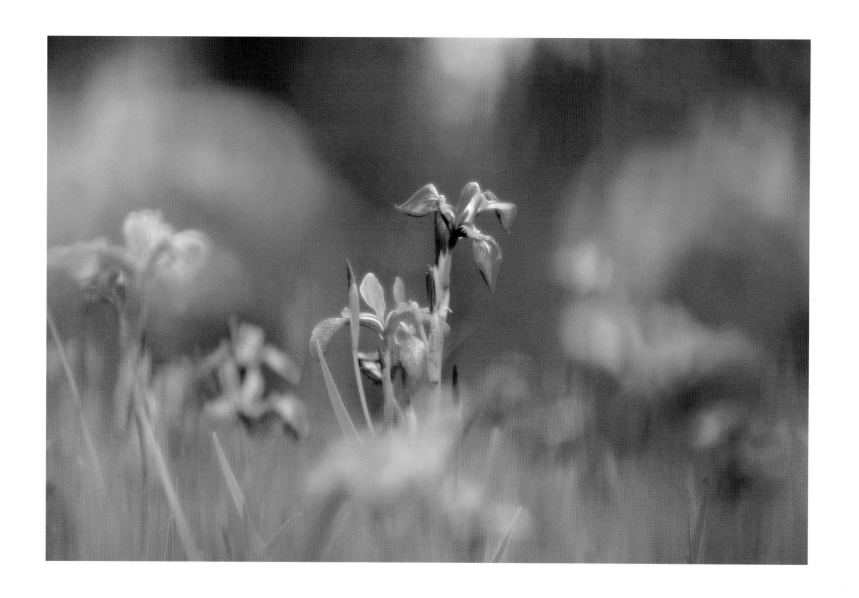

june twenty-seven DAY 7-seven

8:18 pm

South Sioux City Public Library
2121 Dakota Avenue
South Sioux City, NE 68776

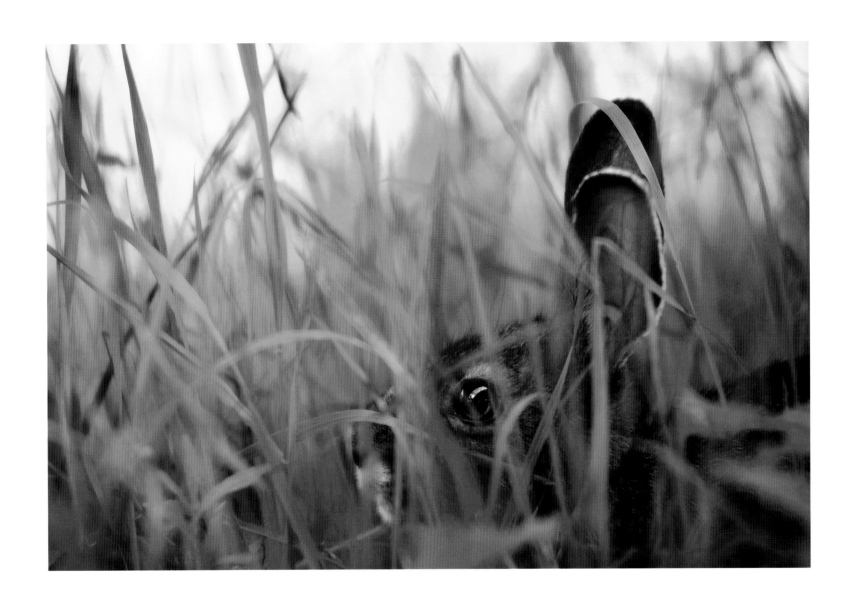

june DAY 8-eight

8:51 am

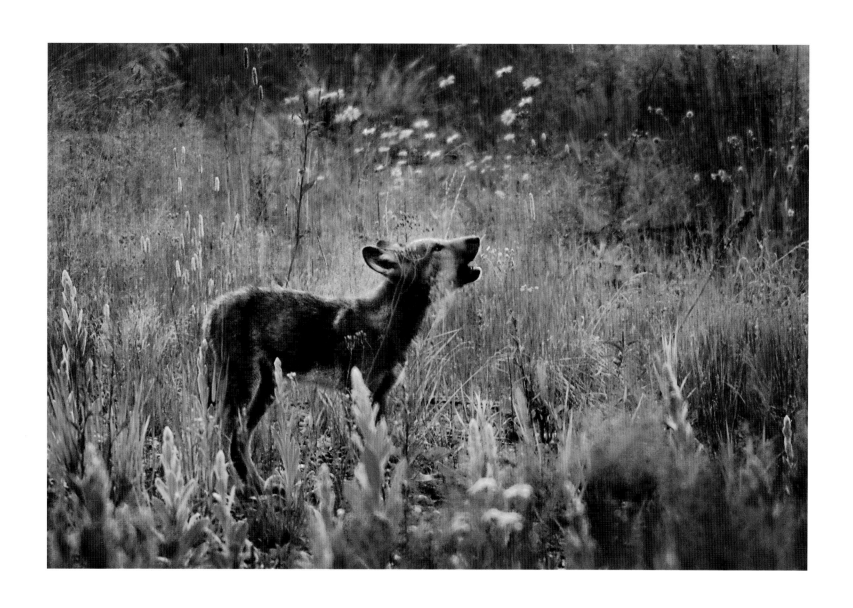

june twenty-nine DAY 9

9:16 pm

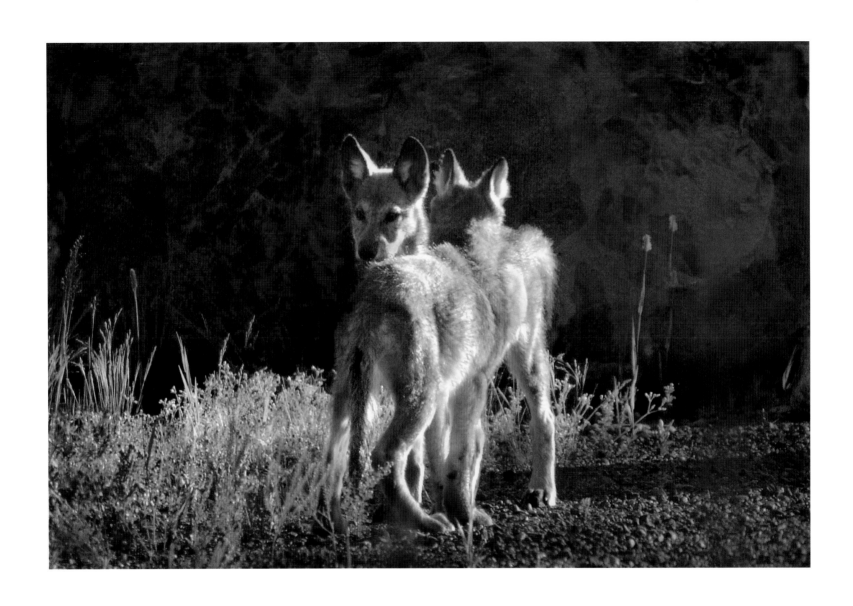

j u n e   DAY  10   t h i r t y

6 : 41 a m

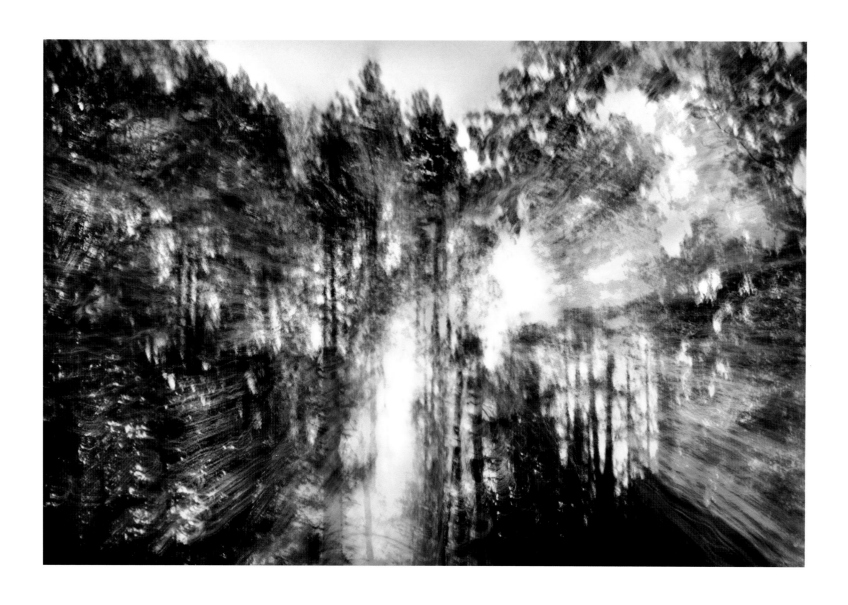

DAY•11

july one

9:31 pm

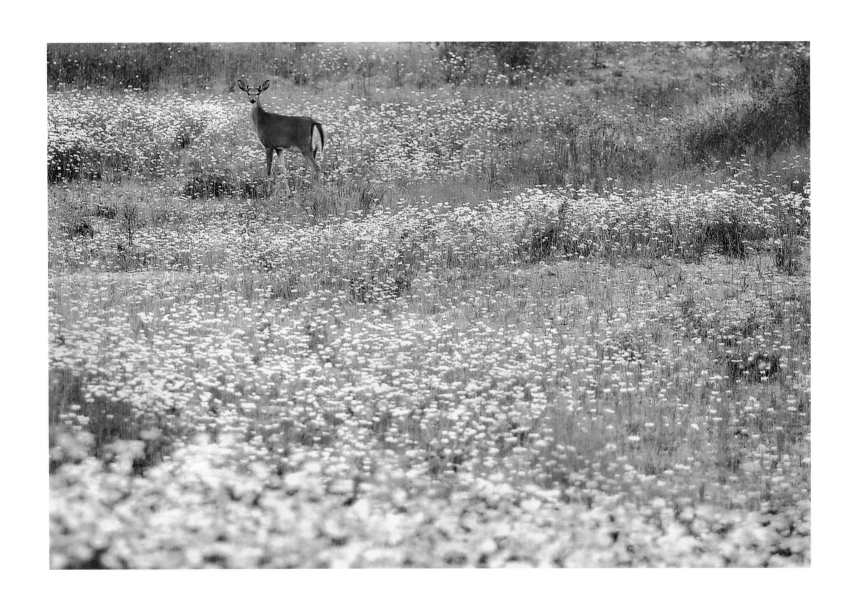

DAY 12

7:25 pm

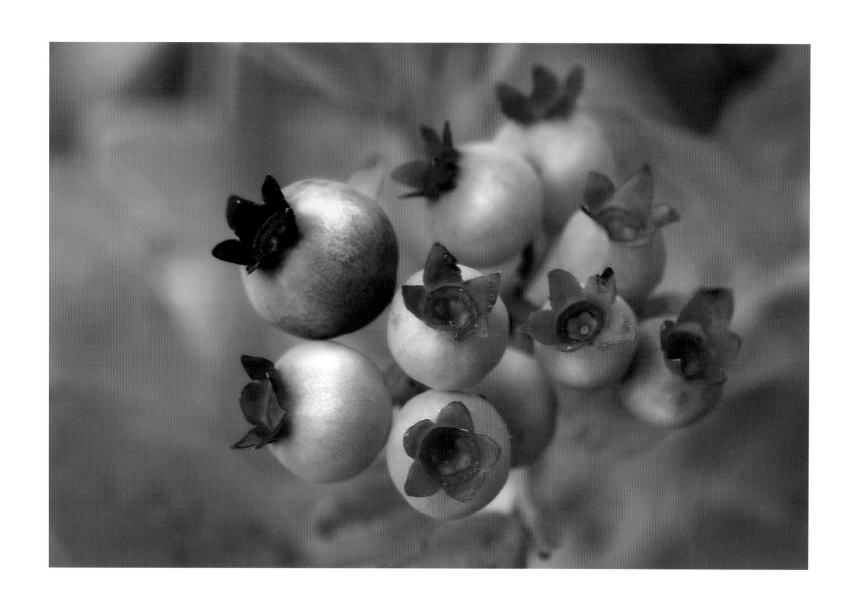

DAY 13

3:45 pm

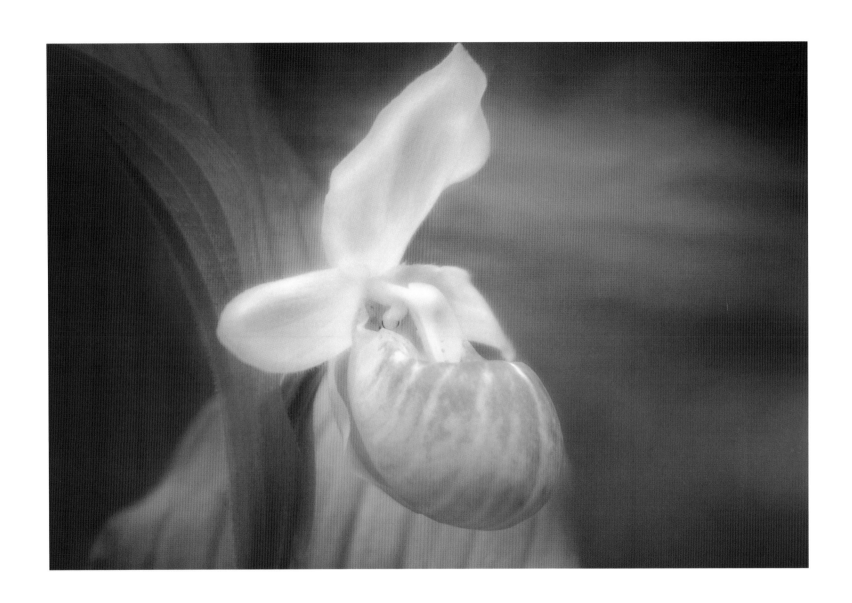

j u l y   f o u r   DAY 14

5 : 1 2   p m

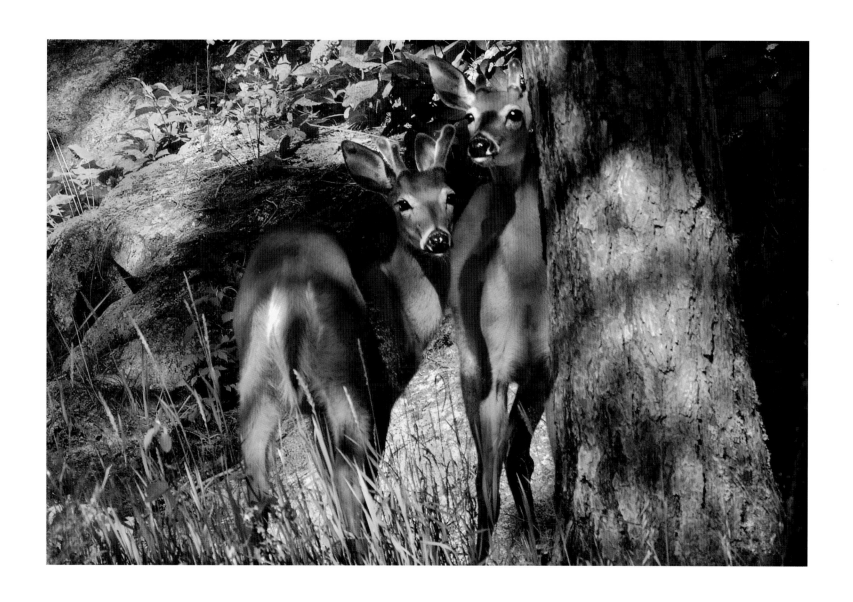

j u l y   f i v e

DAY 15

8 : 3 2   a m

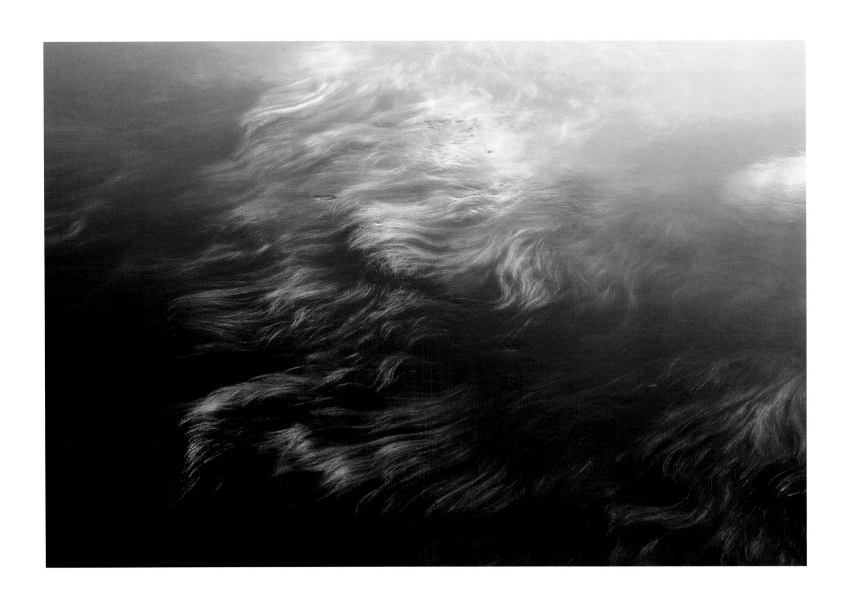

DAY 16

5 : 3 0  pm

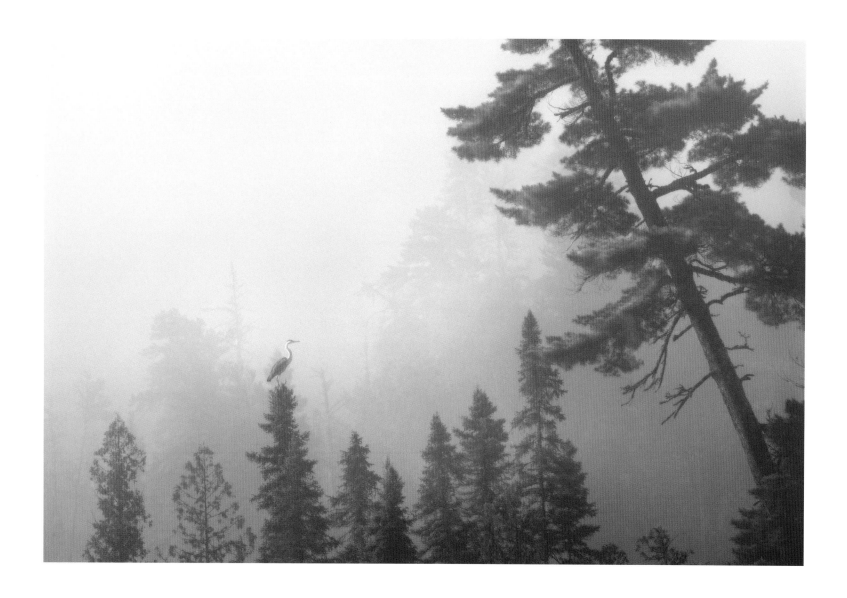

j u l y   s e v e n

6 : 3 2   a m

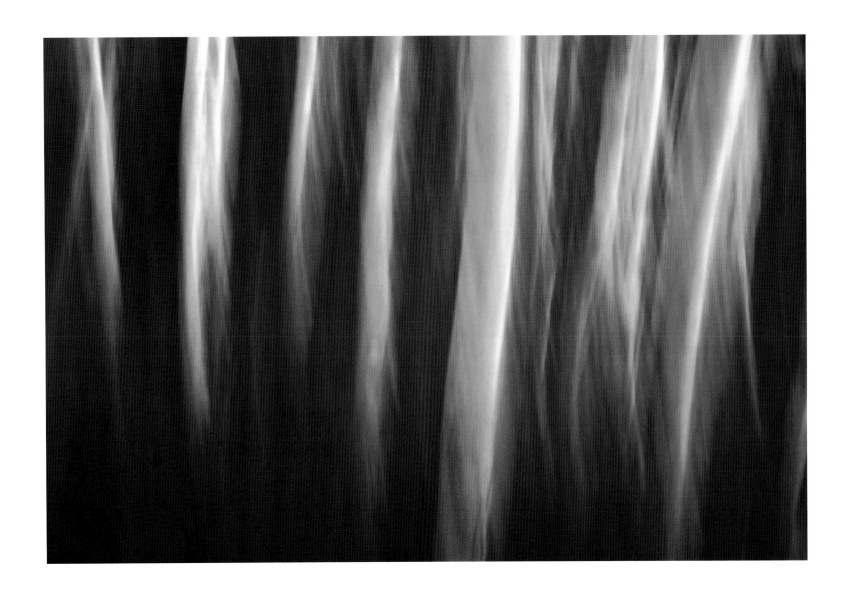

july eight

9.00 pm

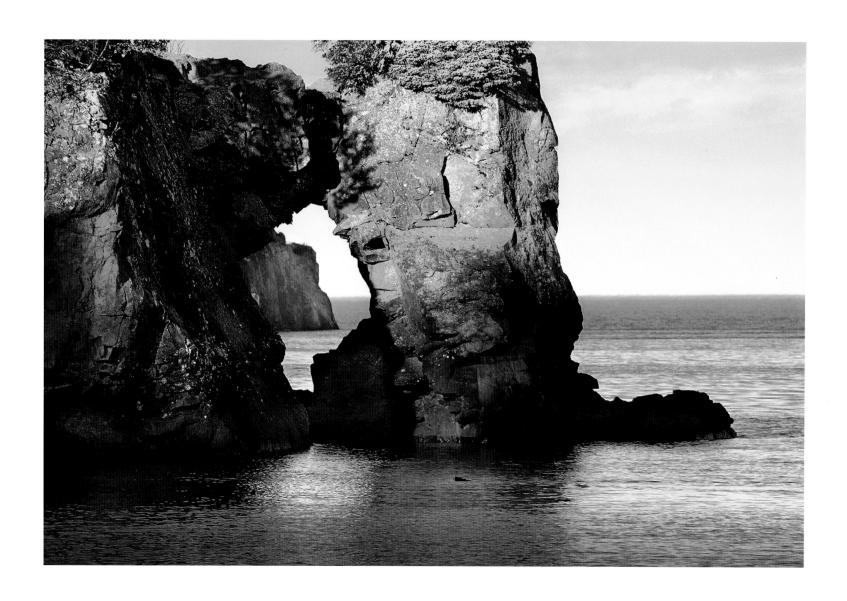

DAY 19

july nine

7.45 pm

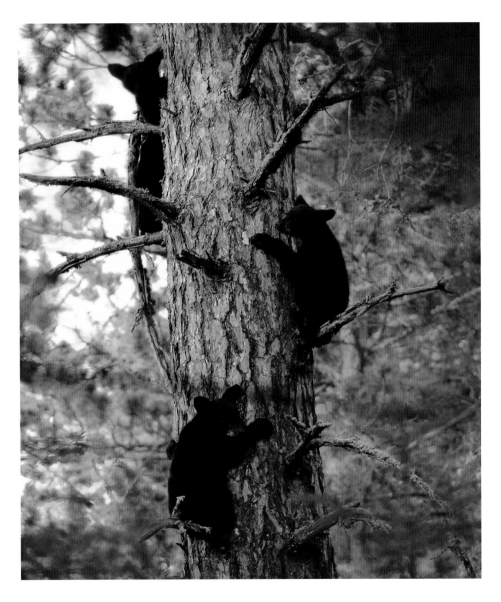

DAY 20

july ten

8 51 pm

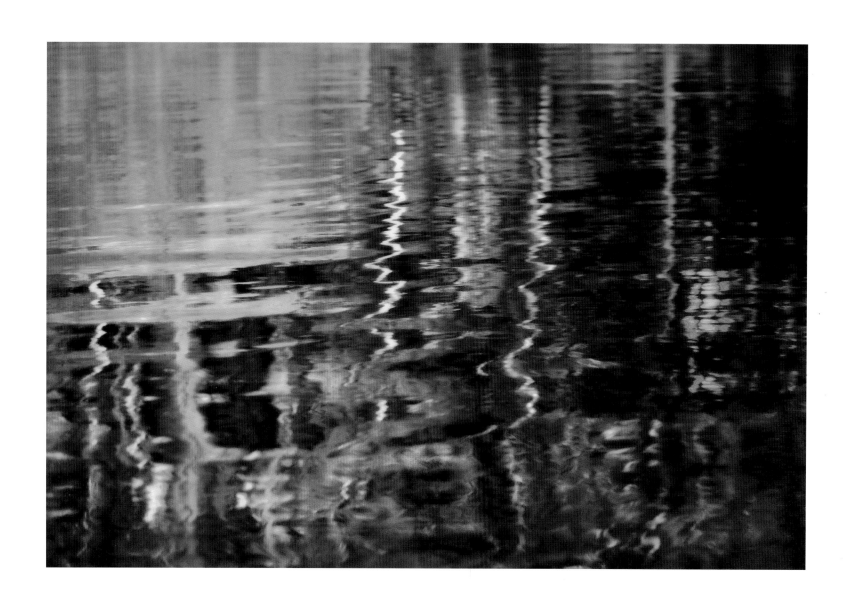

j u l y   e l e v e n   DAY / 21

8 . 3 8   p m

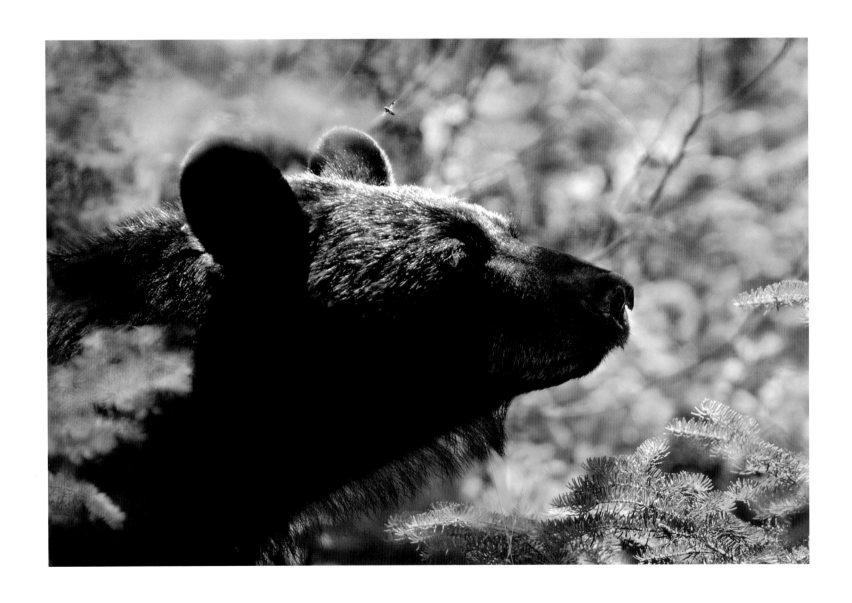

july DAY 22 twelve

1:28 pm

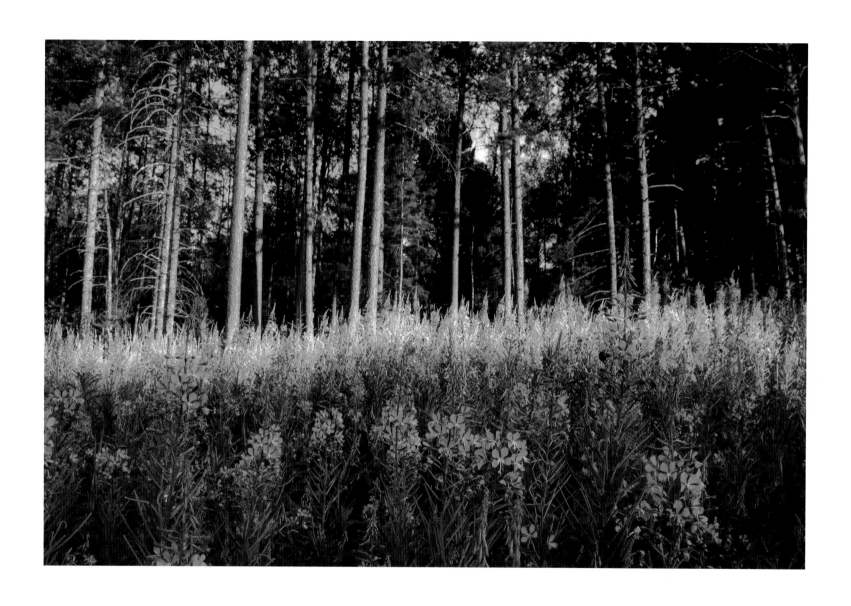

july DAY 23 thirteen

8.28 pm

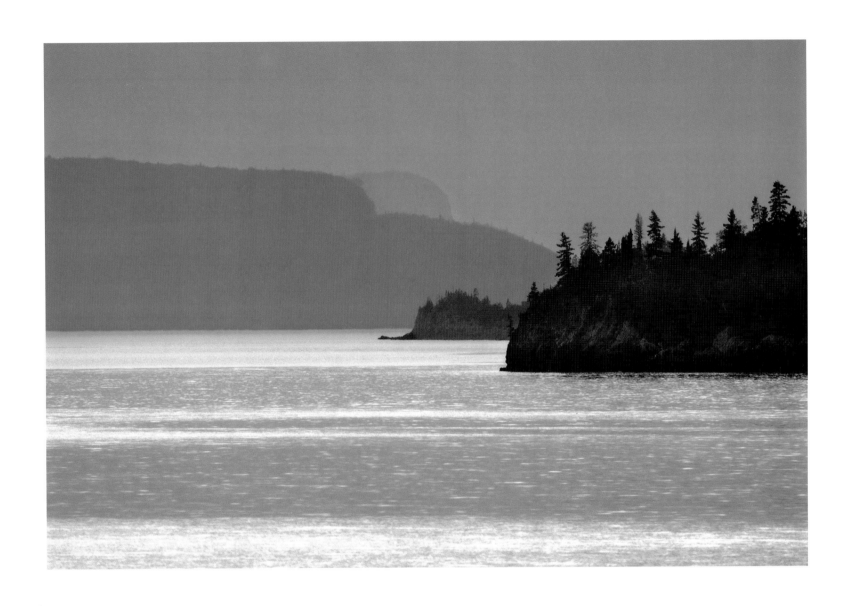

july fourteen

7:51 pm

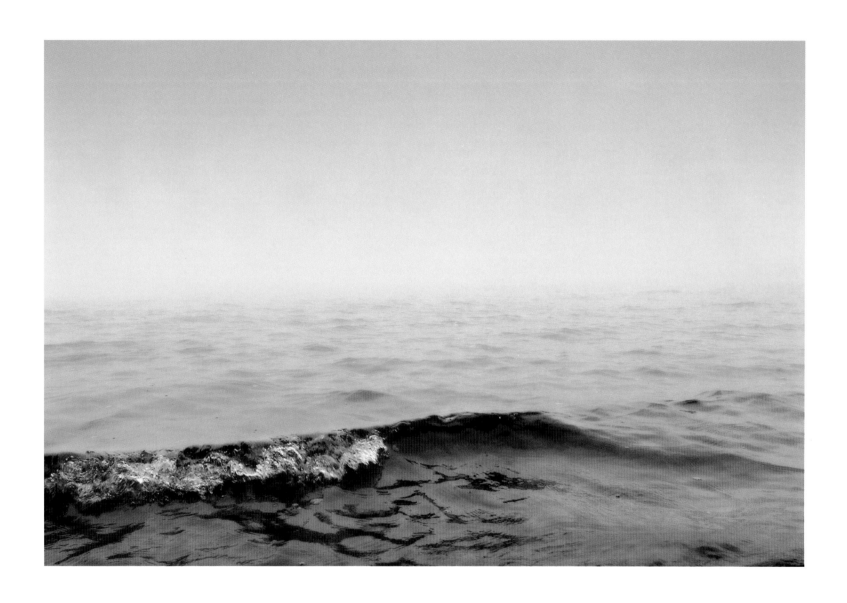

july DAY 25 fifteen

8 . 09 pm

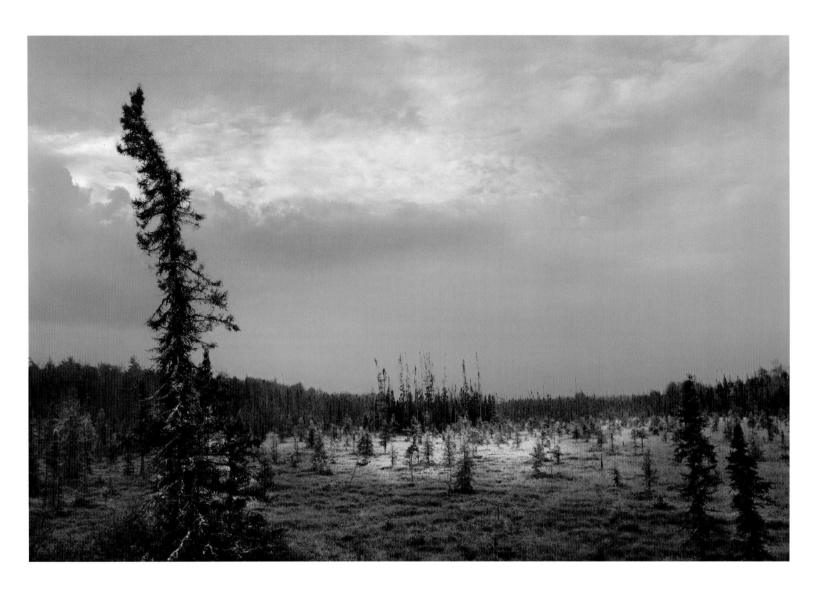

july sixteen DAY 26

8:11 am

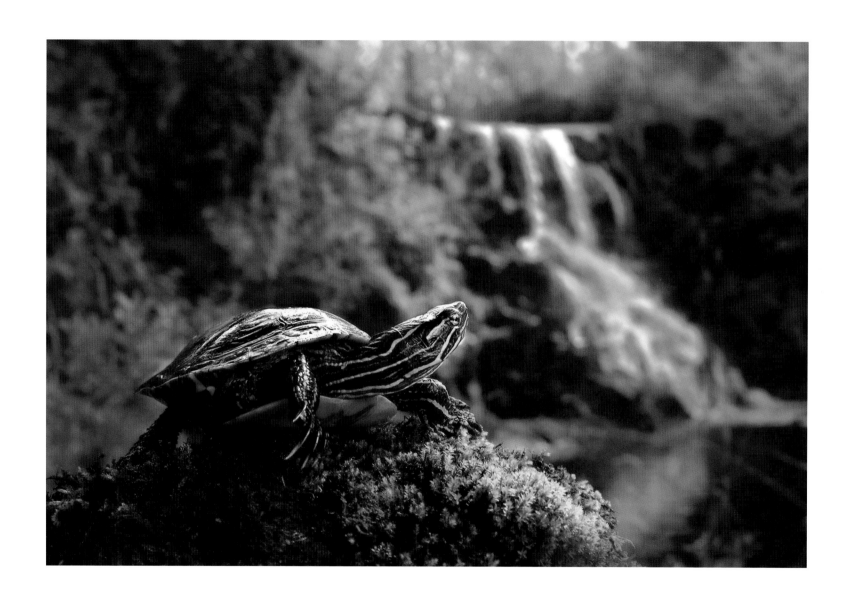

july seventeen DAY 27

5:11 pm

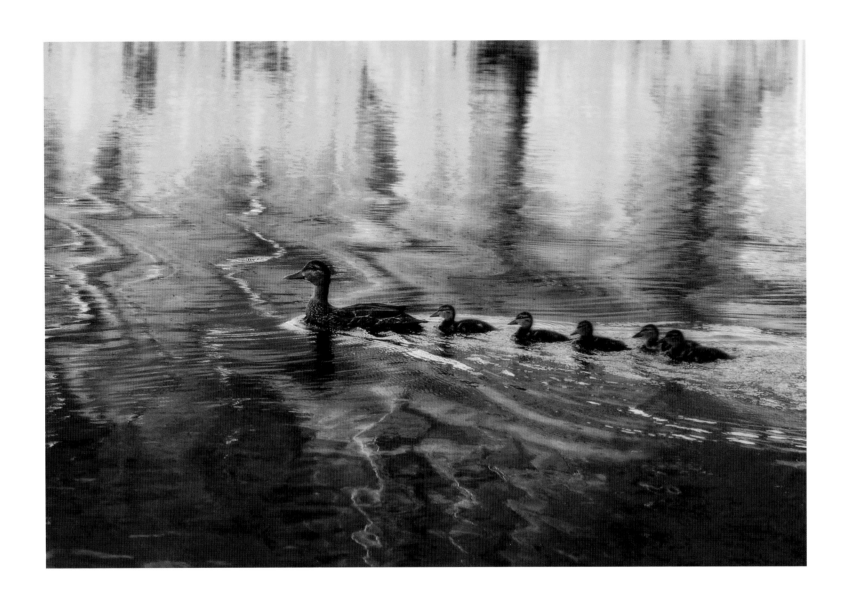

july eighteen

7:41 pm

july nineteen DAY 29

5:58 pm

j u l y DAY 30 t w e n t y

5 . 4 8  a m

july DAY 32 twenty-two

9:01 pm

july DAY 33 twenty-three

10:47 am

j u l y   t w e n t y - f o u r   DAY 34

8 : 2 2   p m

4 : 3 8   p m

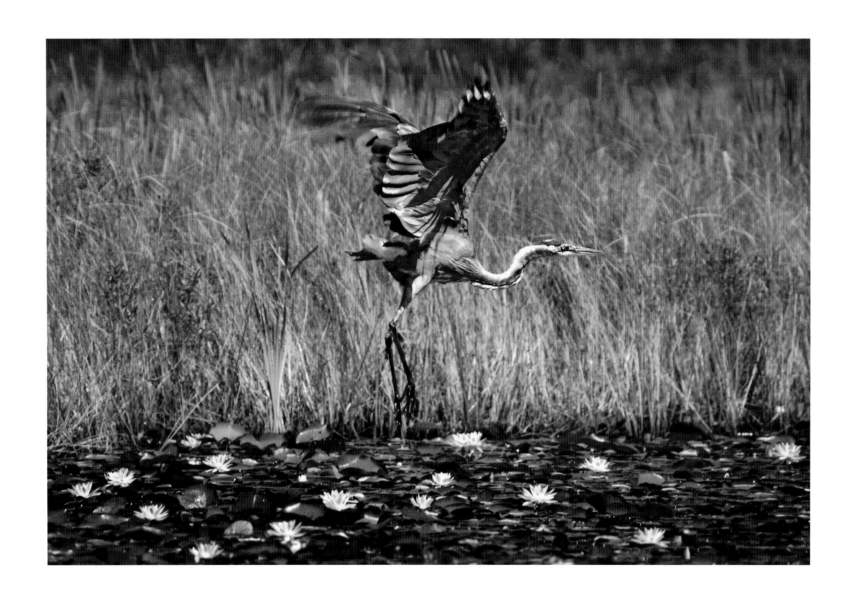

july twenty-six

1:50 pm

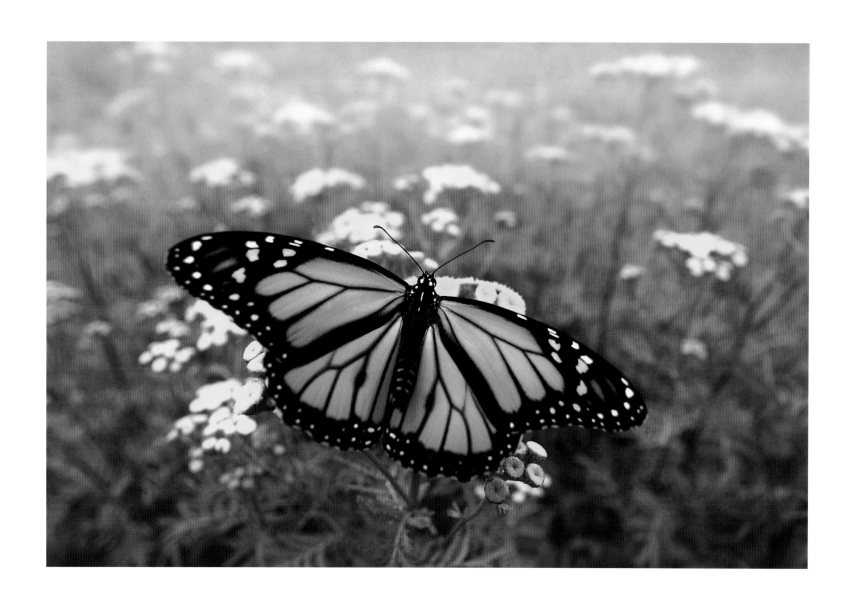

july twenty-seven DAY 37

7:33 pm

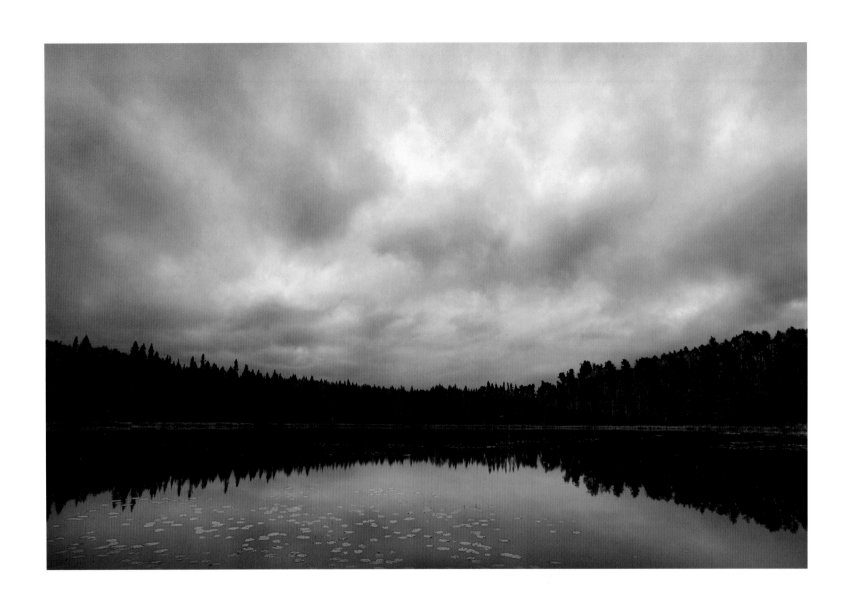

july twenty-eight DAY 98

7.28 pm

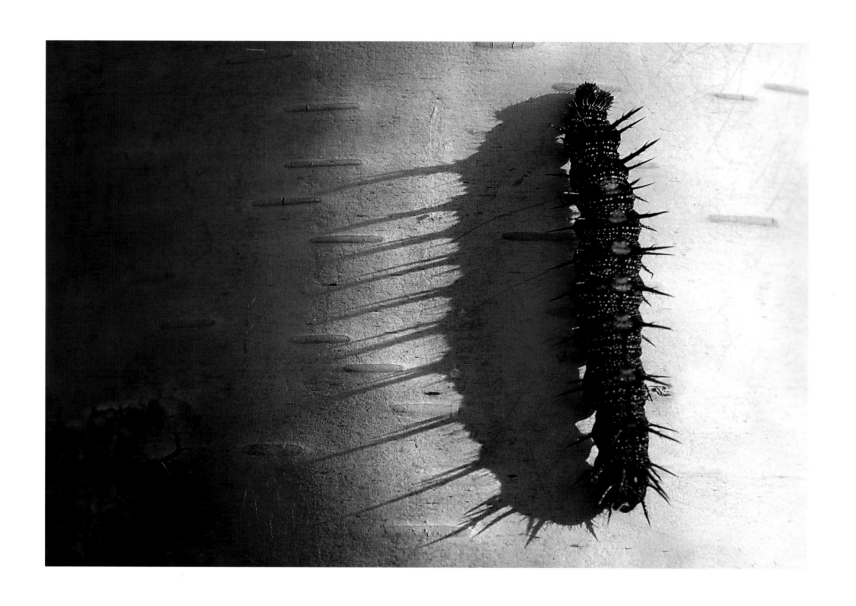

july **DAY** twenty-nine **39**

7:17 pm

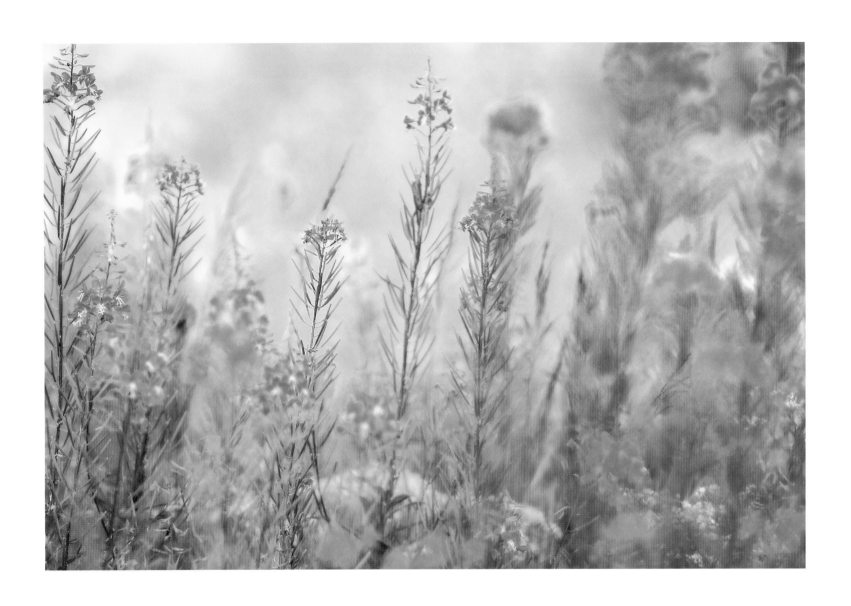

july DAY 40 thirty

7 : 41 pm

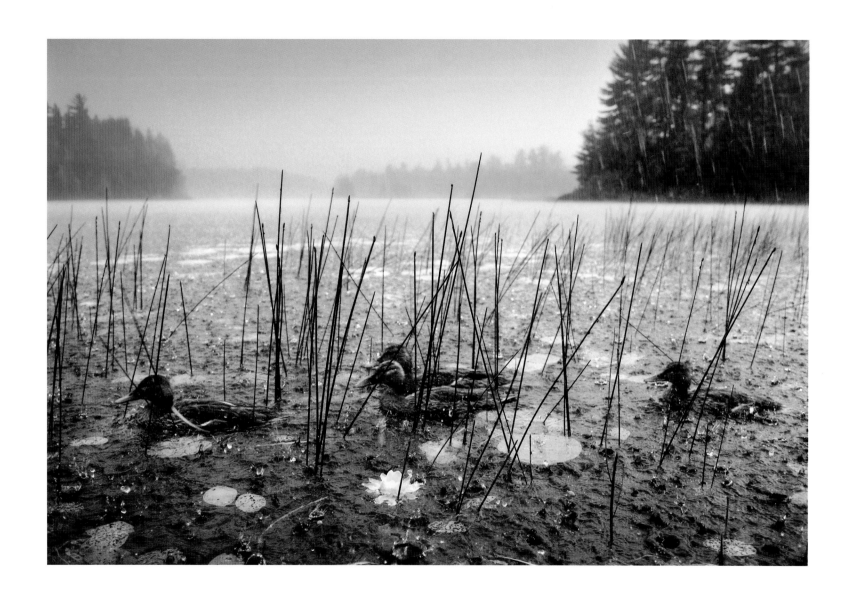

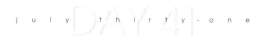

july DAY 41 thirty-one

11:42 am

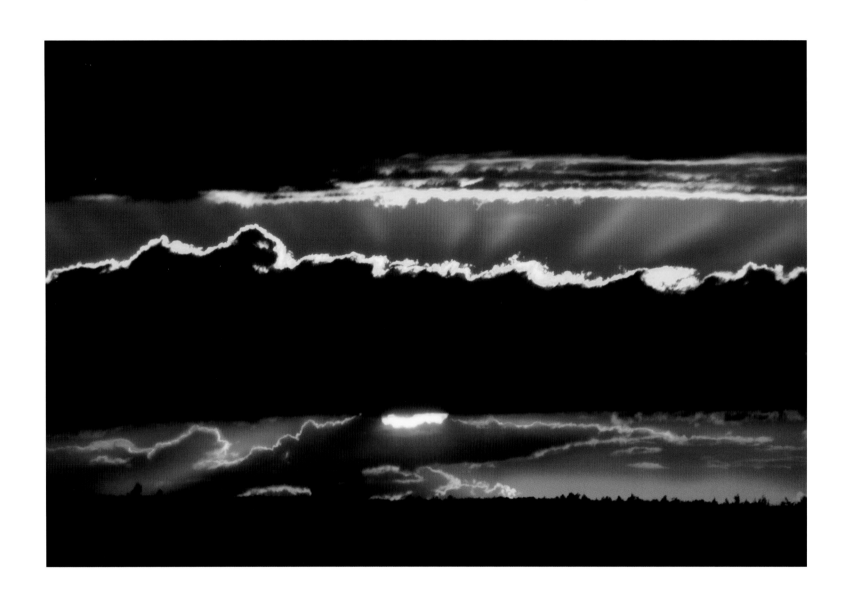

DAY 42
a u g u s t   o n e

8 : 3 5  p m

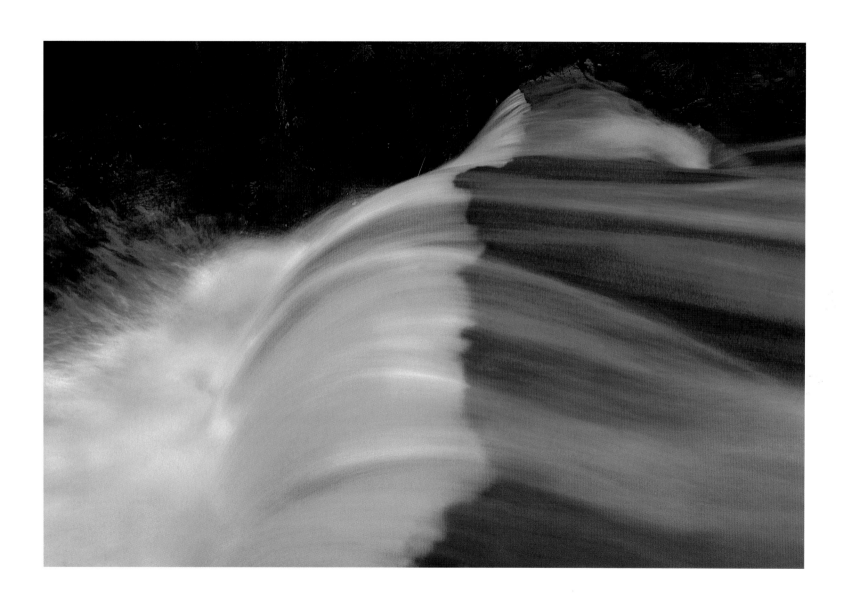

august two DAY 43

6:07 am

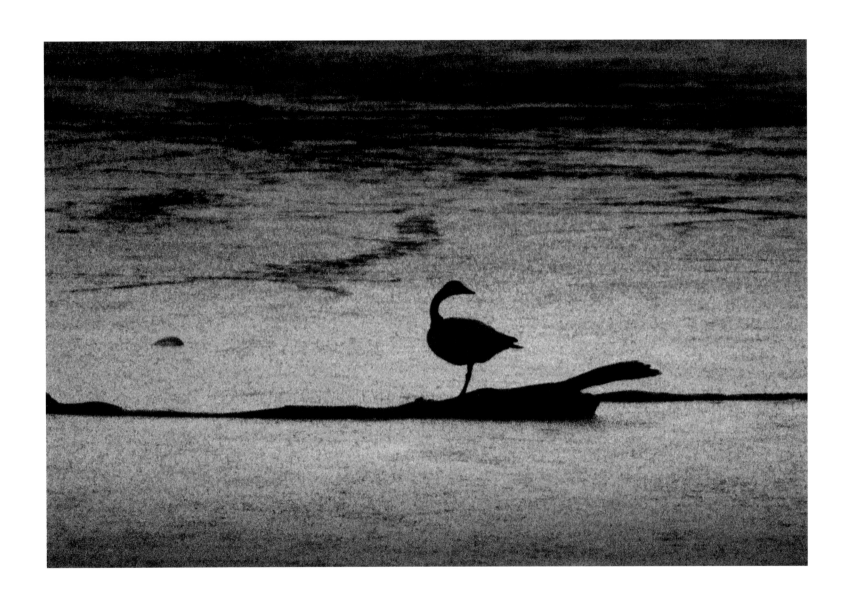

august three

8 52 pm

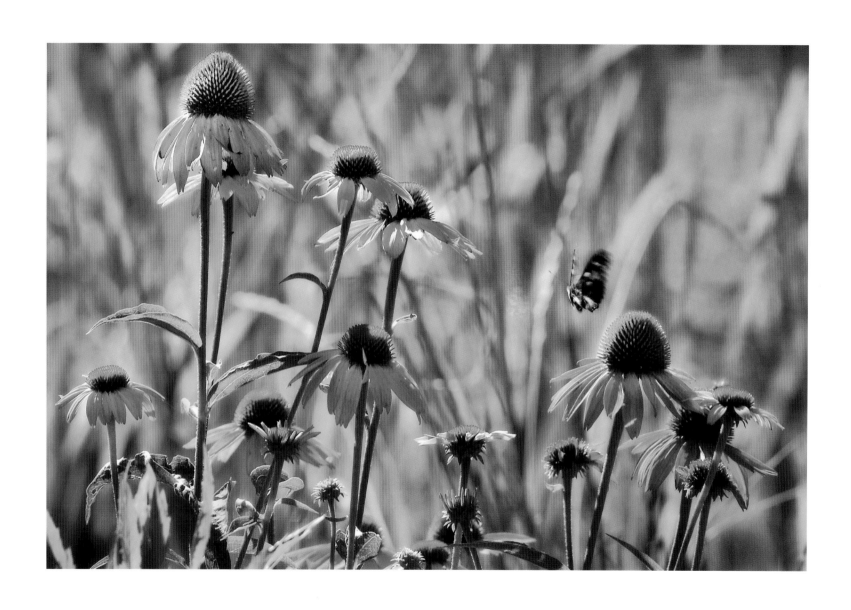

august four

9:11 am

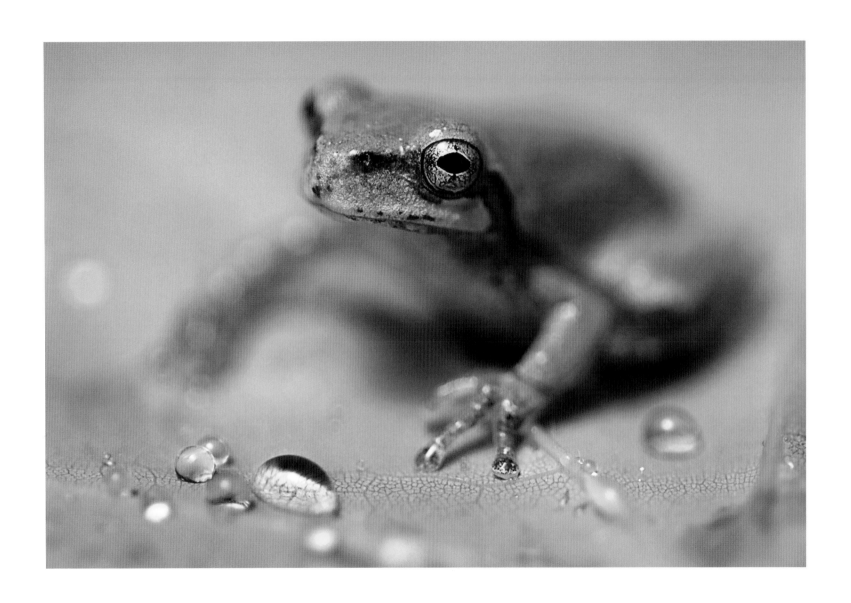

august five DAY 46

8:38 am

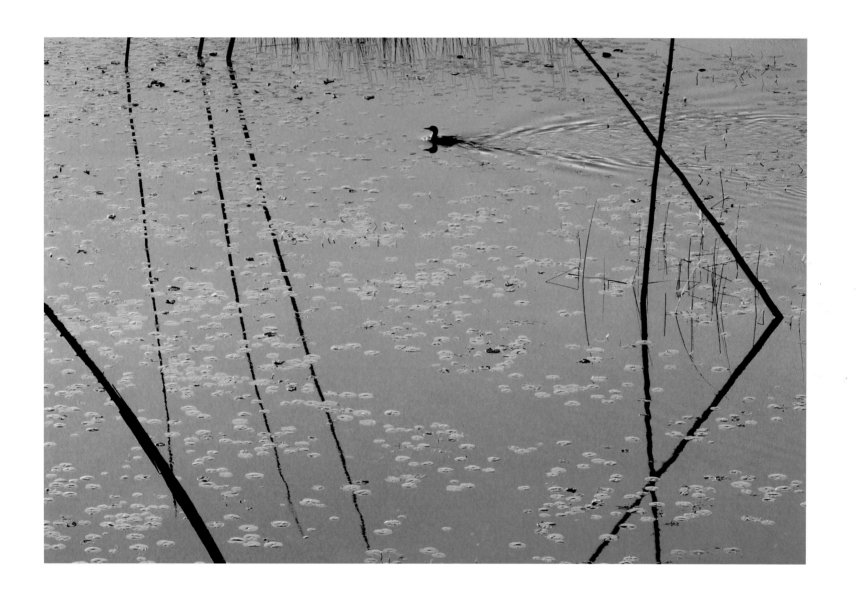

august six DAY 47

8:00 pm

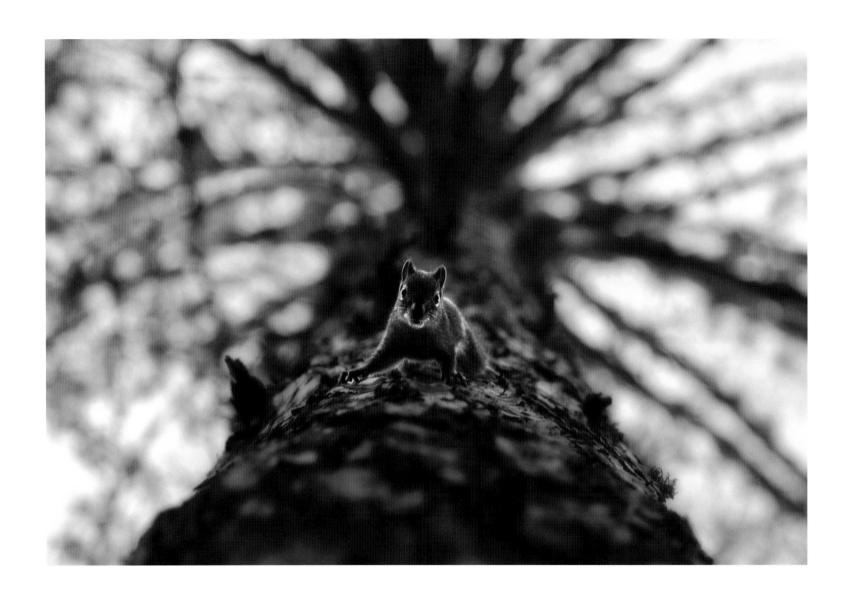

august seven DAY 48

7:01 pm

august eight DAY 49

8:22 pm

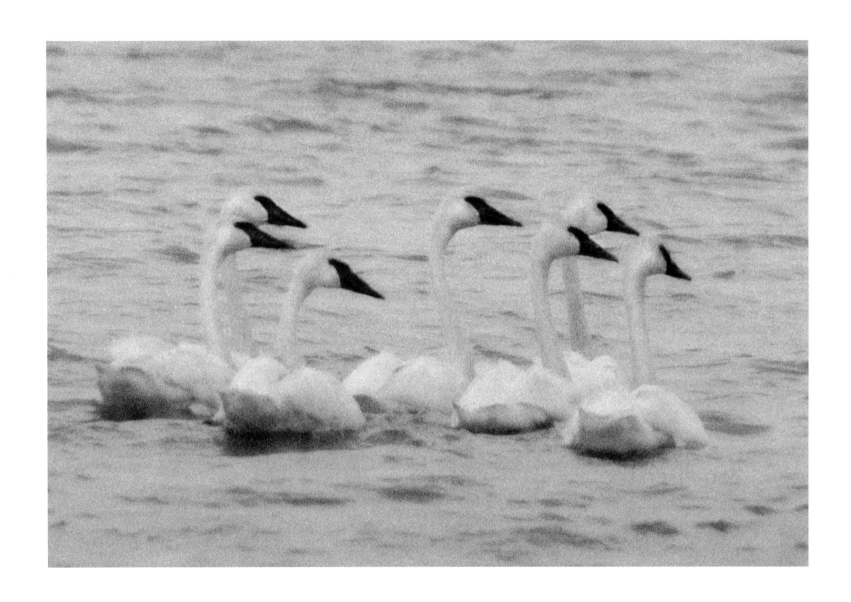

 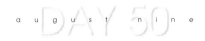
1 : 3 2 pm

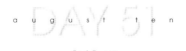

august ten DAY 51

9:15 am

august DAY 52 eleven

7 : 18 am

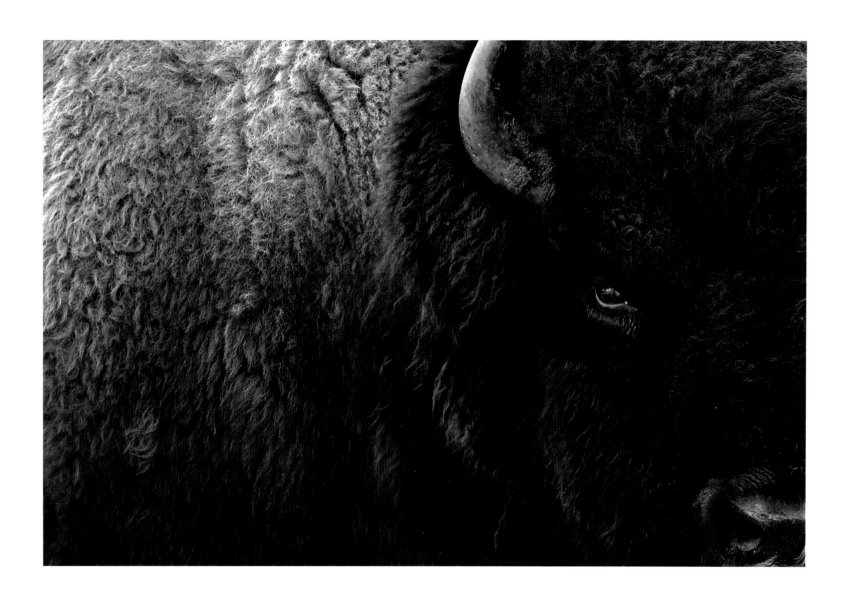

9:00 am

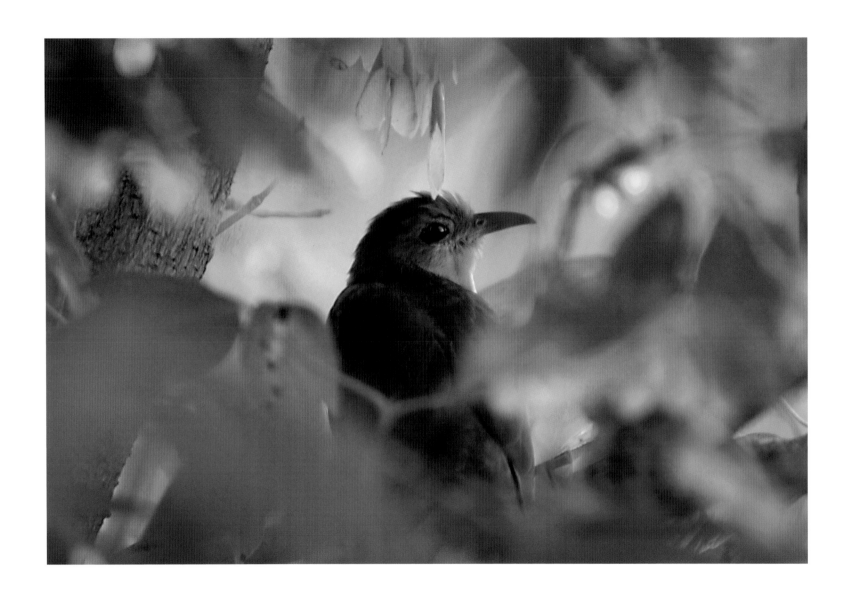

august thirteen DAY 54

7 45 pm

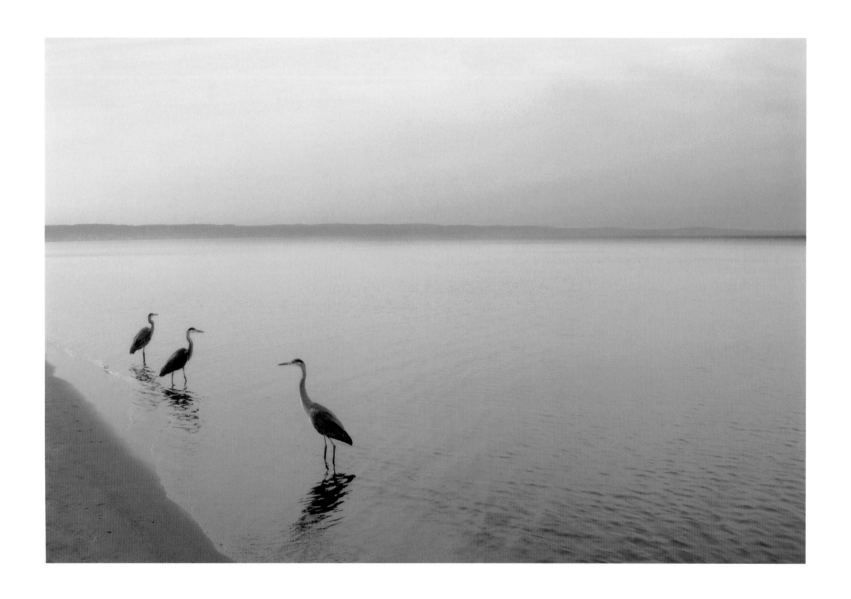

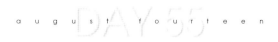
august fourteen DAY·55

7:28 pm

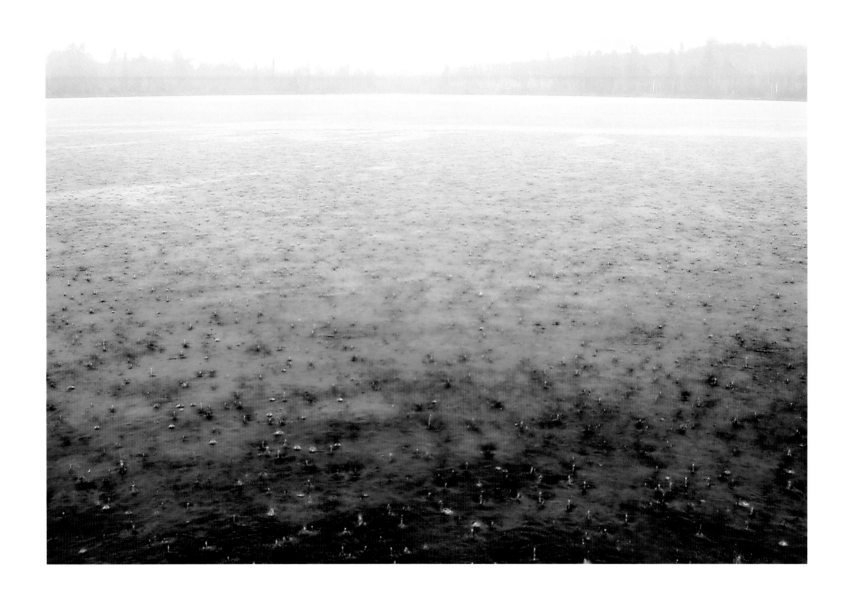

august DAY 56 fifteen

4 53 pm

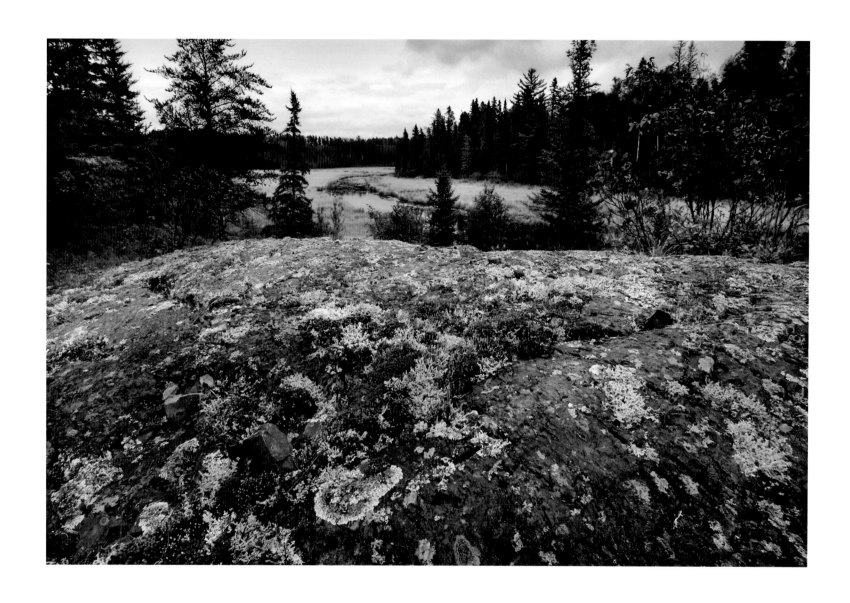

august sixteen DAY 57

1 : 40 pm

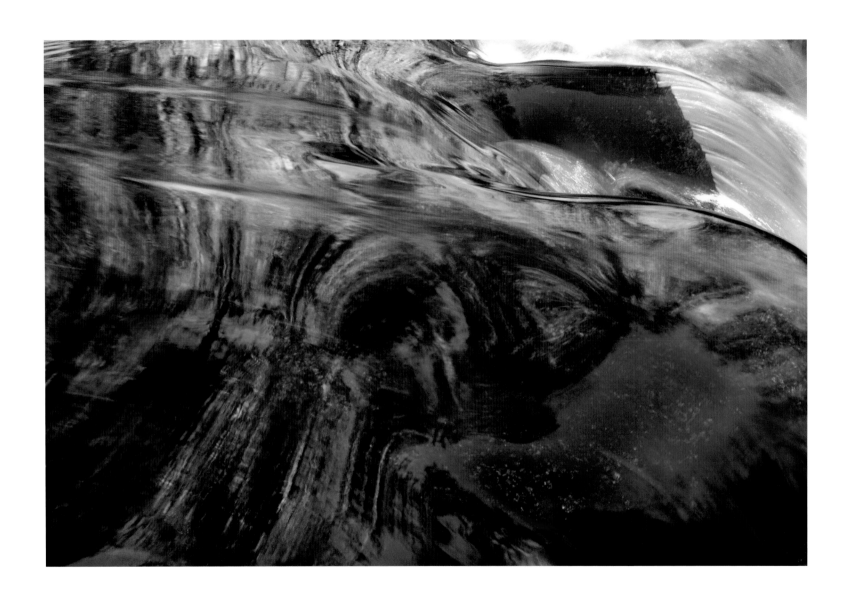

august seventeen DAY 58

11:54 am

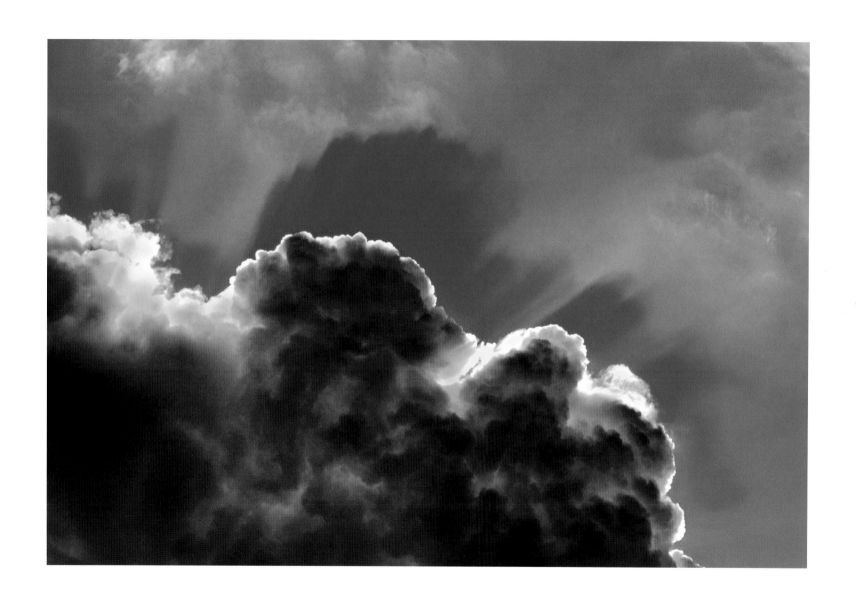

august eighteen  DAY 59

5:48 pm

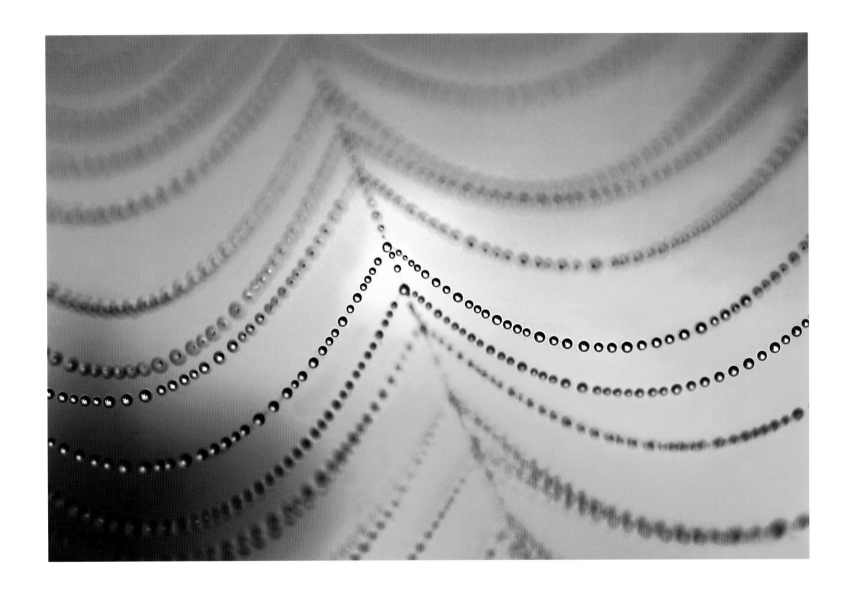

7:14 am

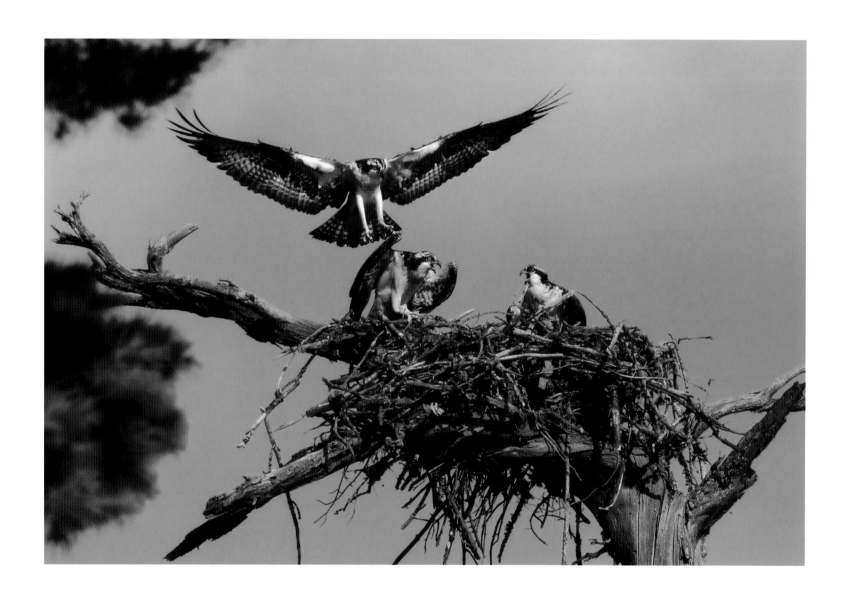

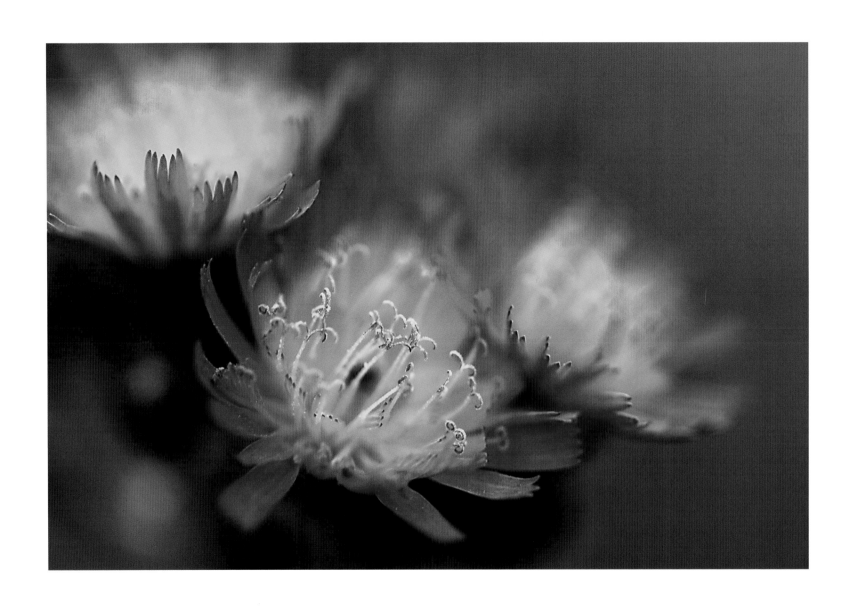

august twenty-one DAY 62

5 : 16 pm

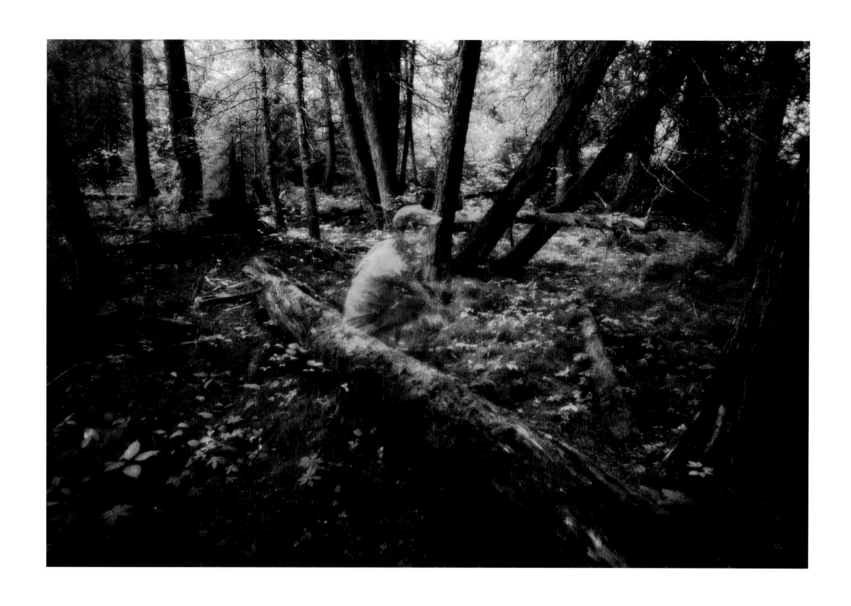

august twenty-two DAY 63

8:43 pm

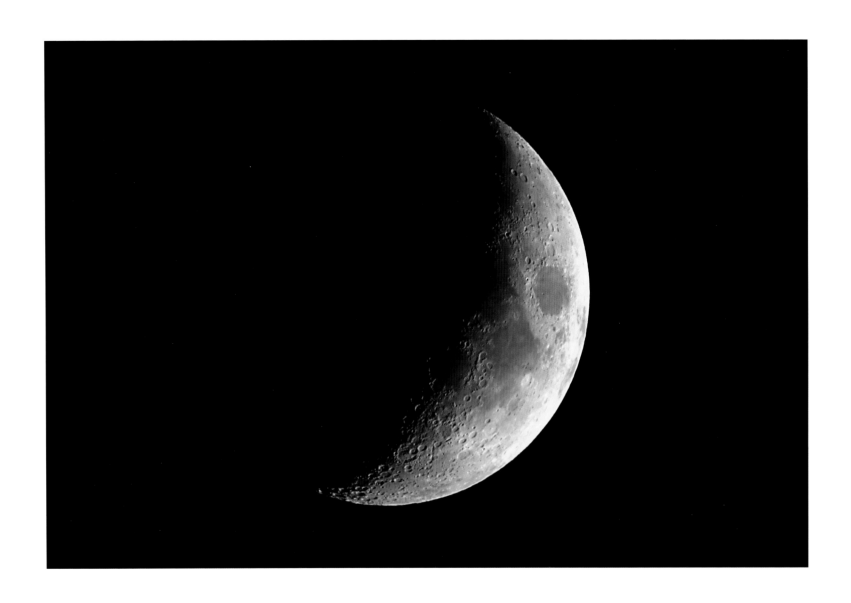

august twenty-three **DAY 64**

8:50 pm

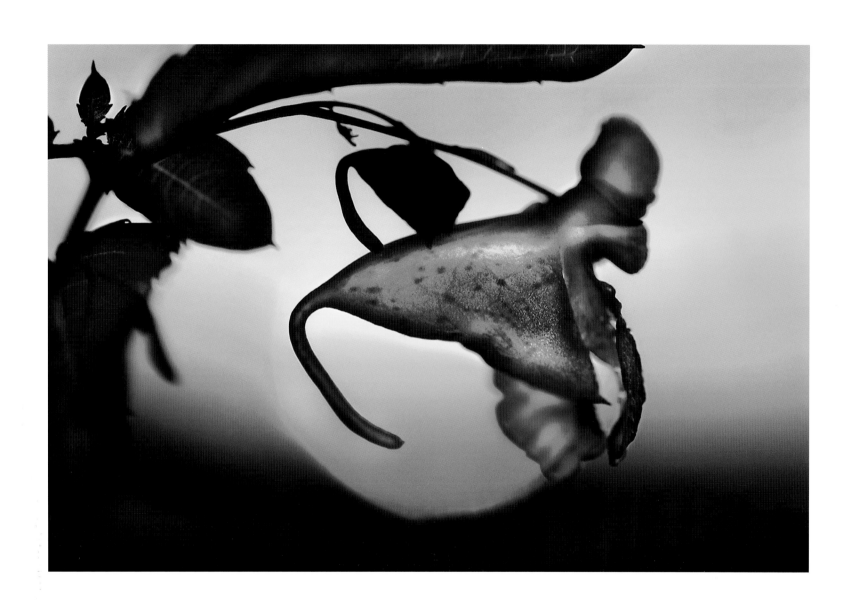

august twenty-four DAY 65

7:41 pm

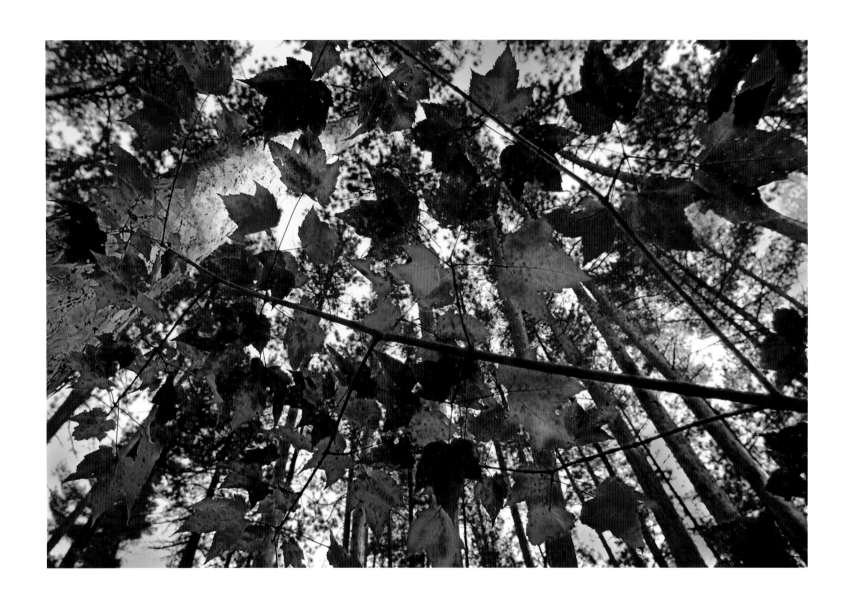

7 : 18 pm

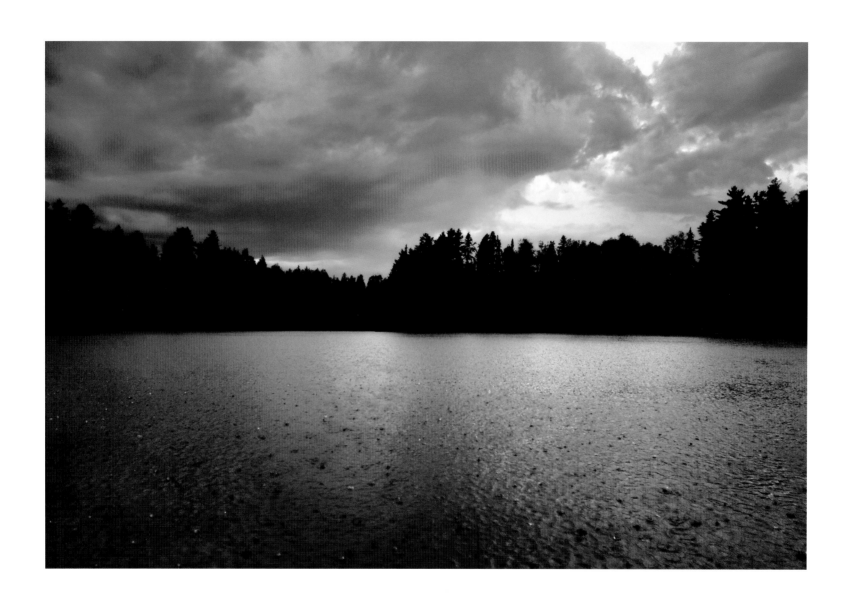

august twenty-six DAY 67

7:47 pm

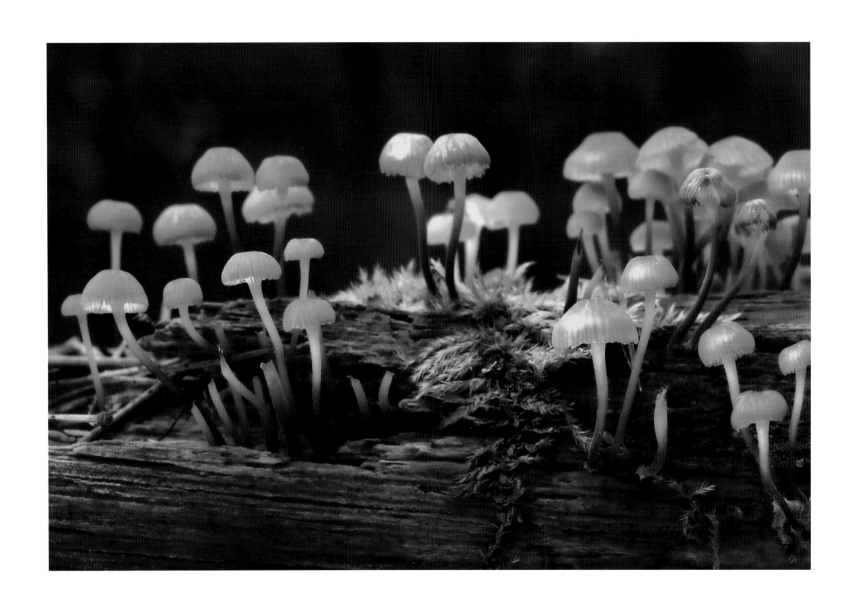

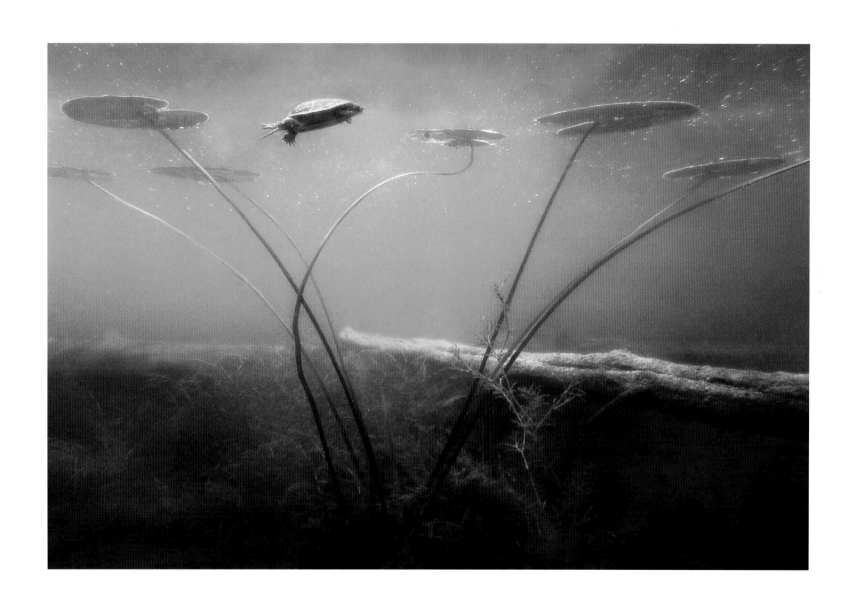

august twenty-eight DAY 69

7:19 pm

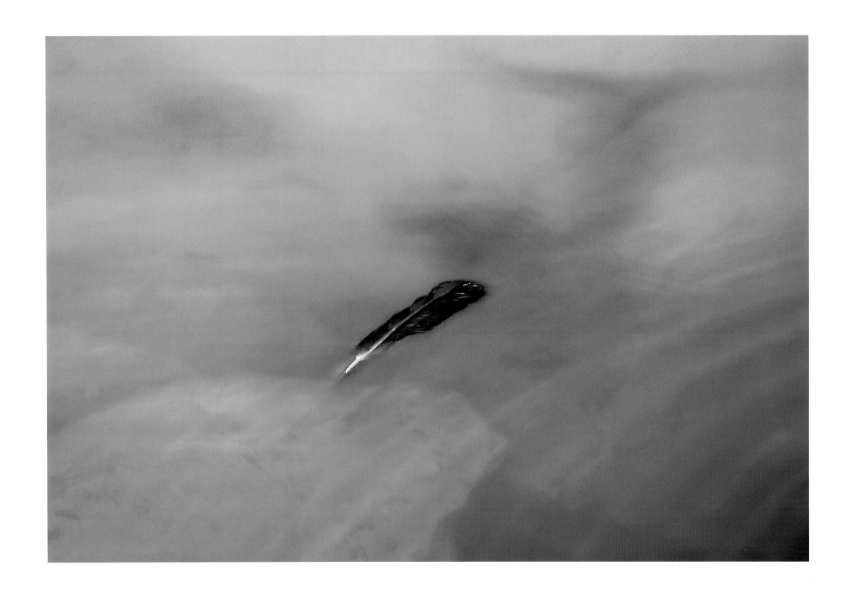

august DAY 70 twenty-nine

8:02 pm

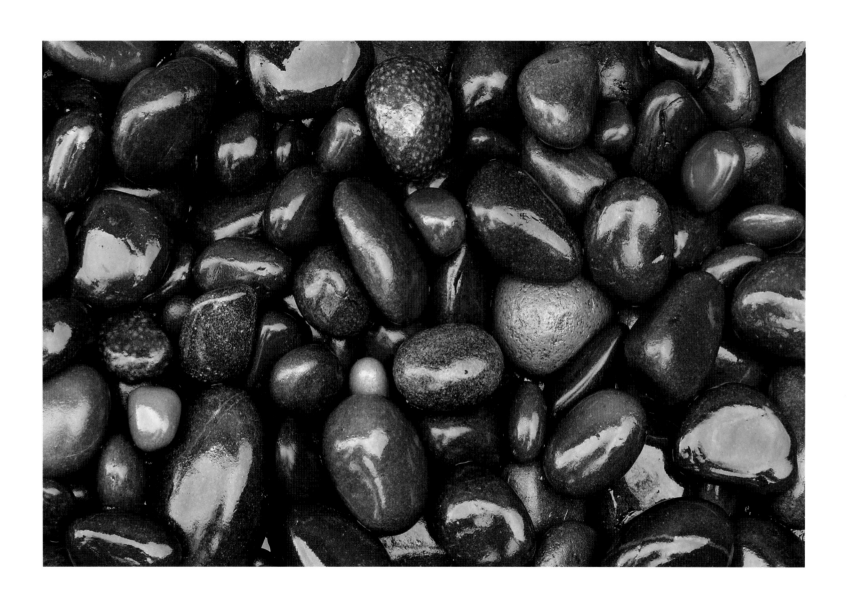

august DAY 71 thirty

5:20 pm

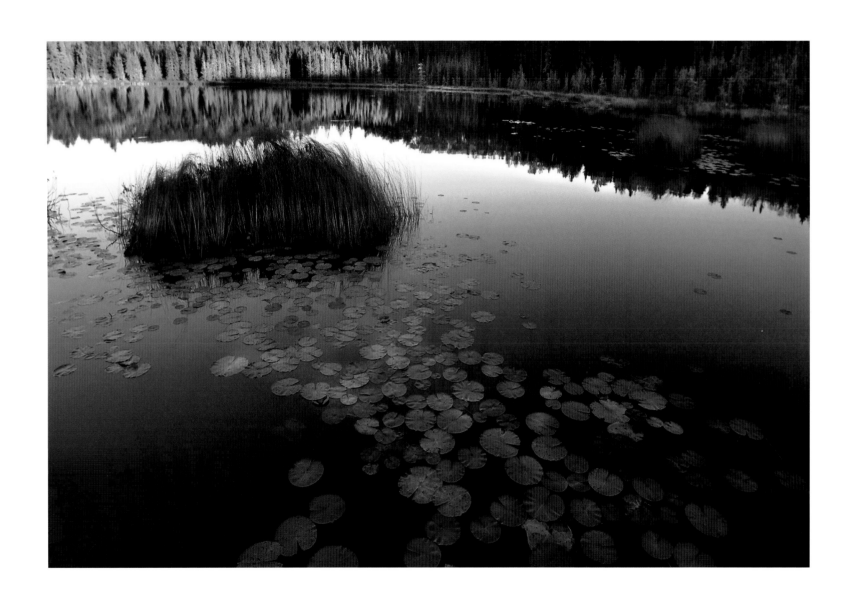

august DAY 72 thirty-one

7:31 pm

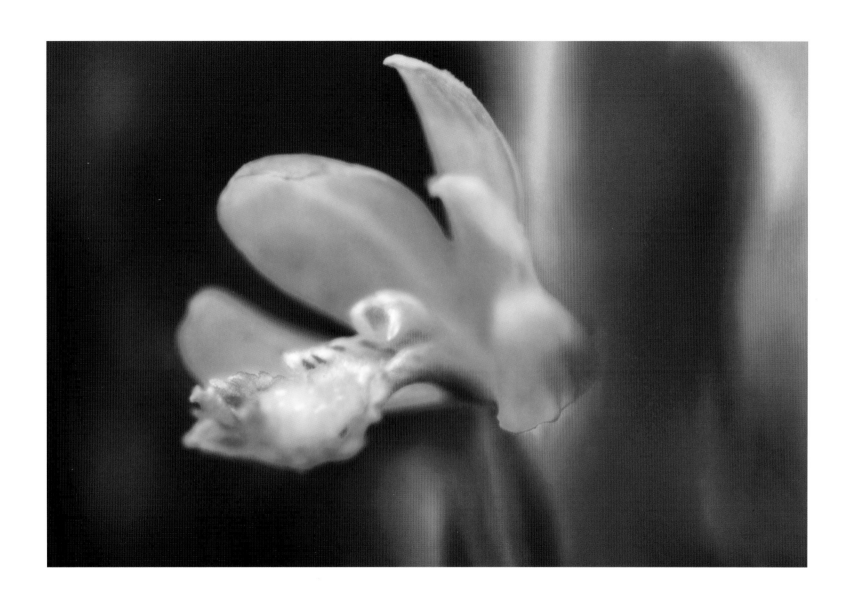

september DAY 73 one

9:25 am

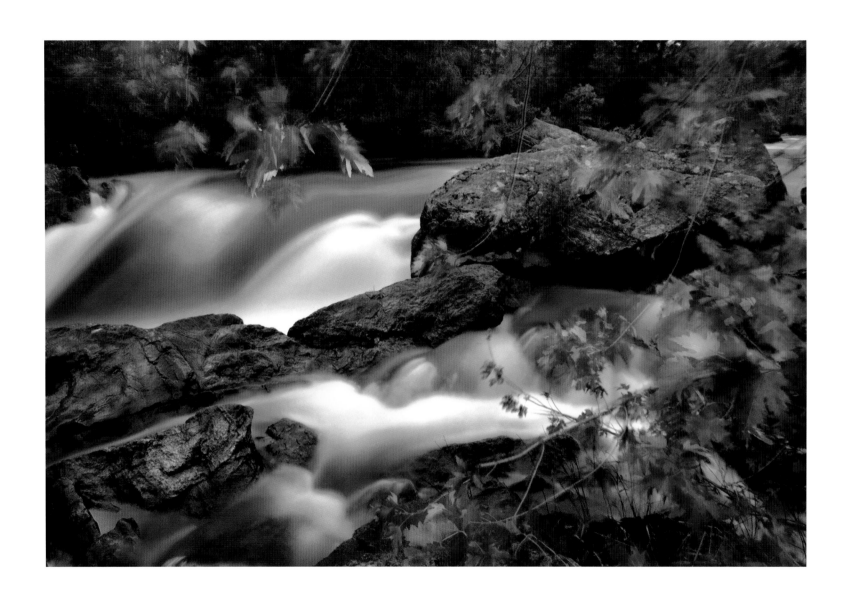

september two DAY 74

8:05 pm

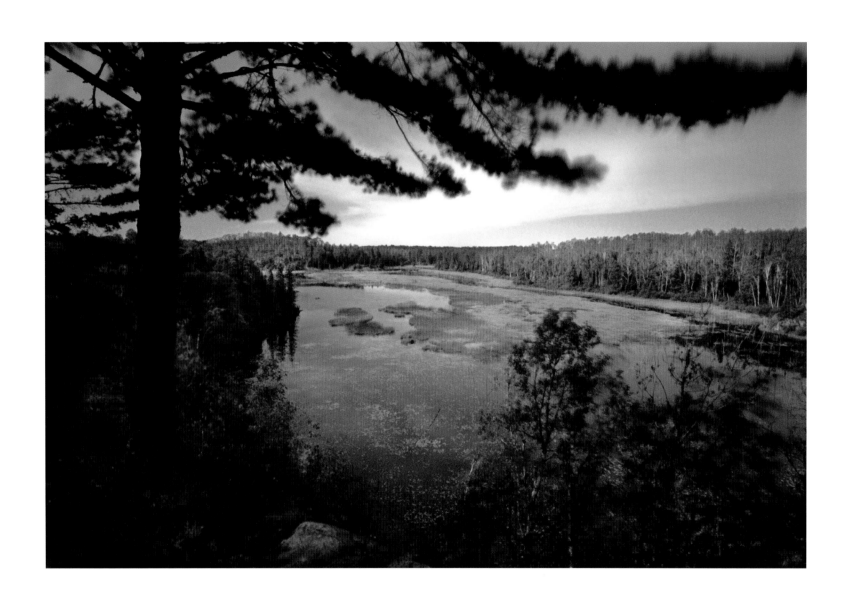

september DAY 75 three

1:23 am

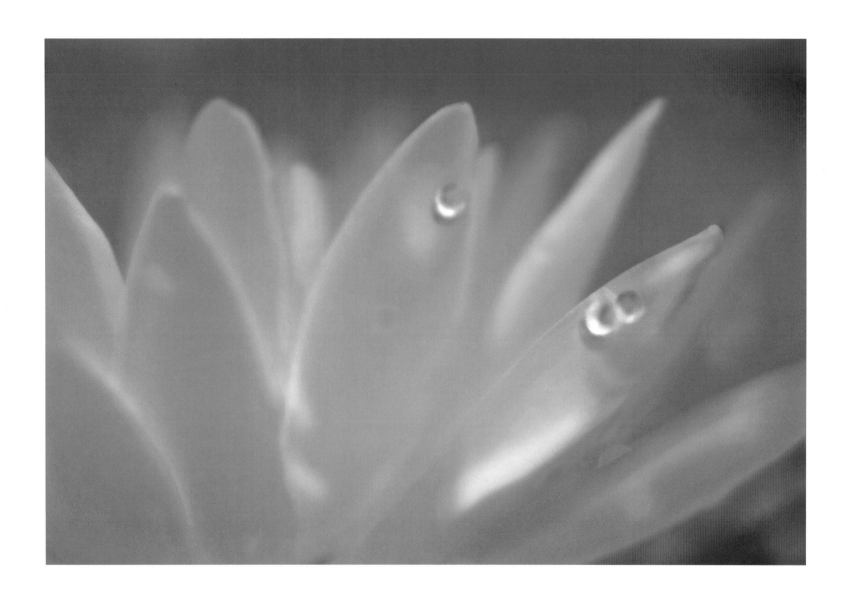

september DAY76 four

5:28 pm

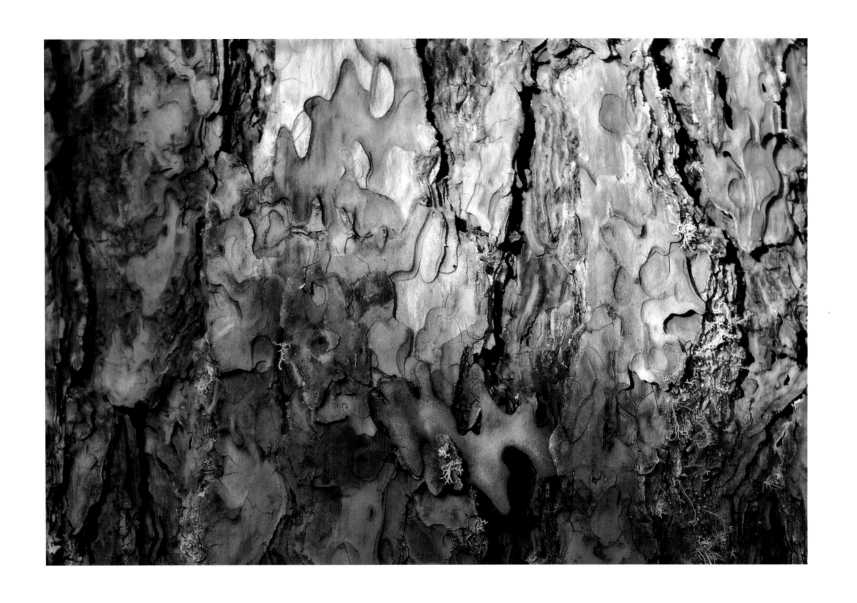

september // five

DAY / 7

6 39 pm

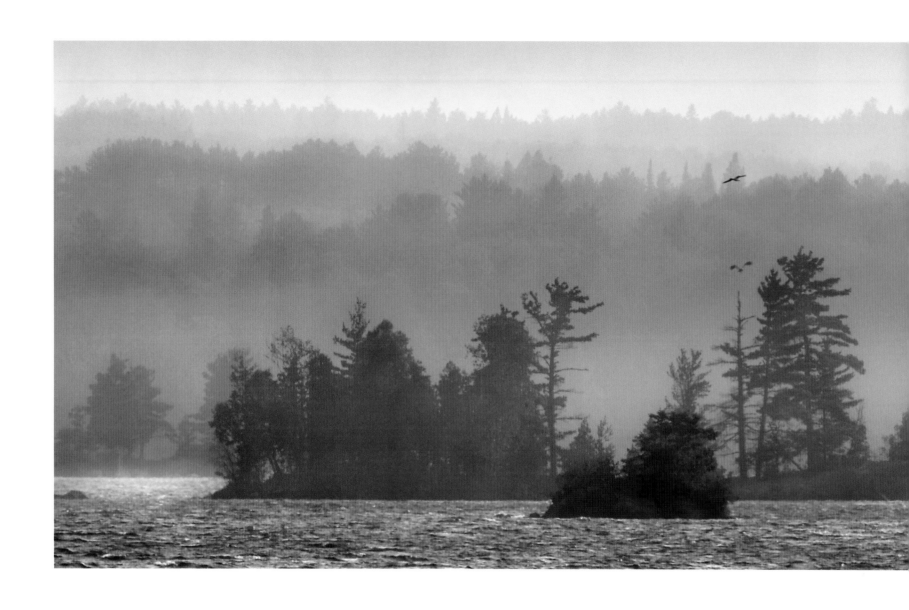

september DAY 78 six

5:27 pm

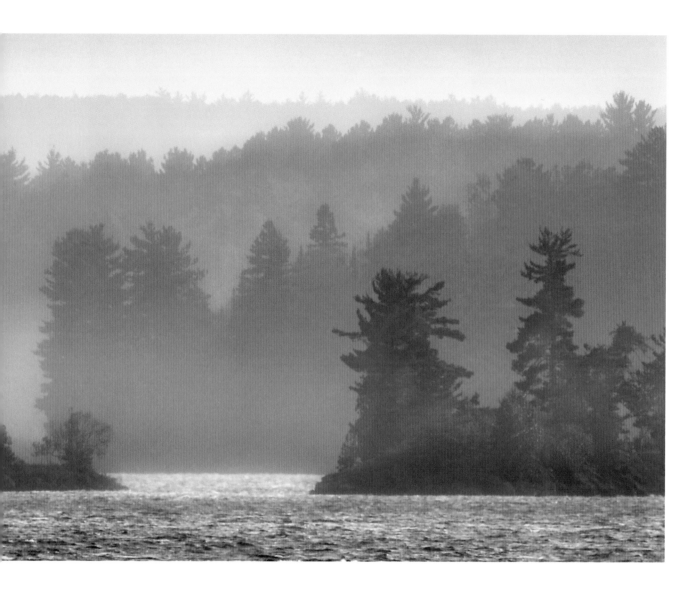

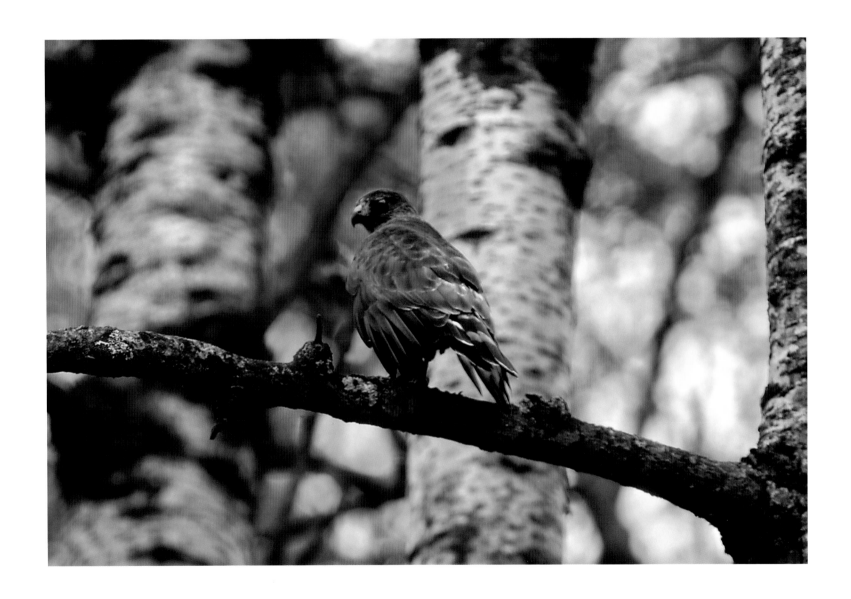

september DAY 79 seven

4 31 pm

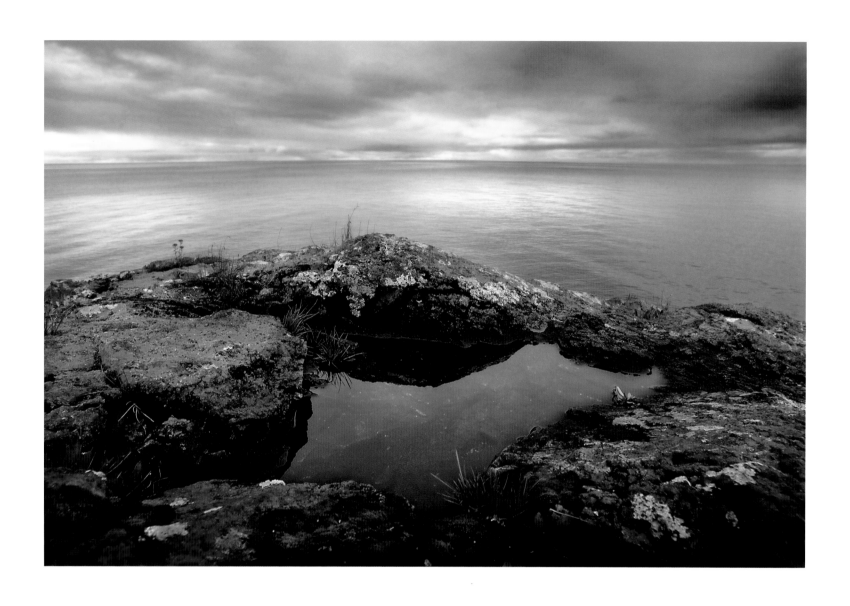

september DAY 30 eight

6 45 pm

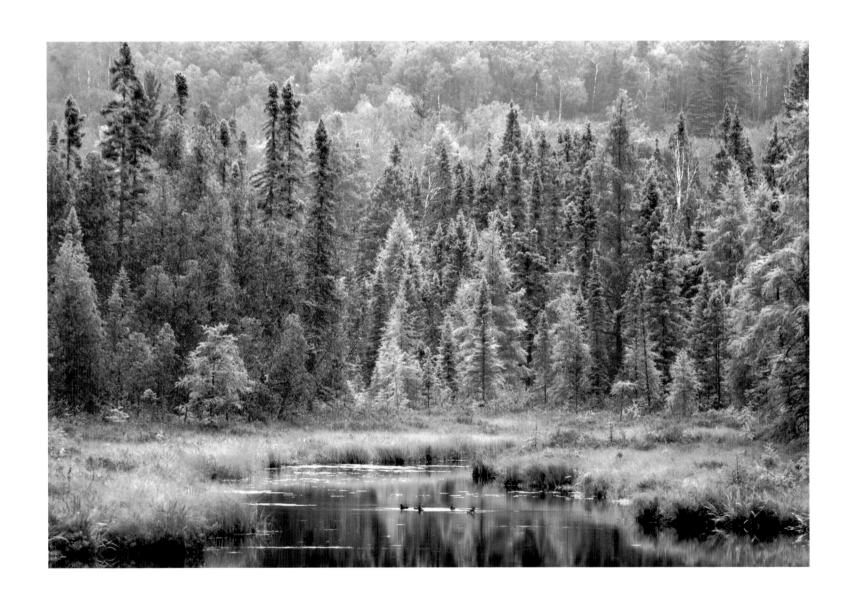

september DAY 81 nine

6:52 am

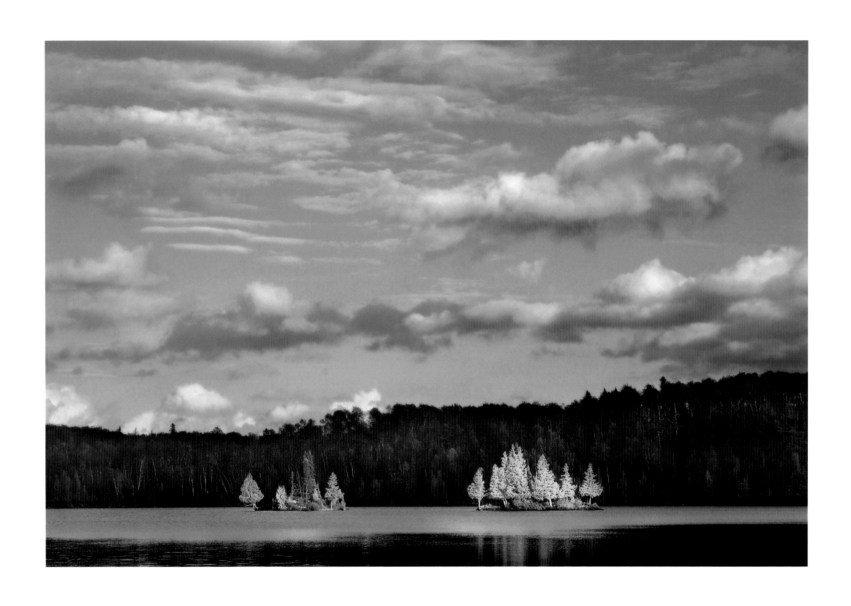

september DAY 82 ten

5:01 pm

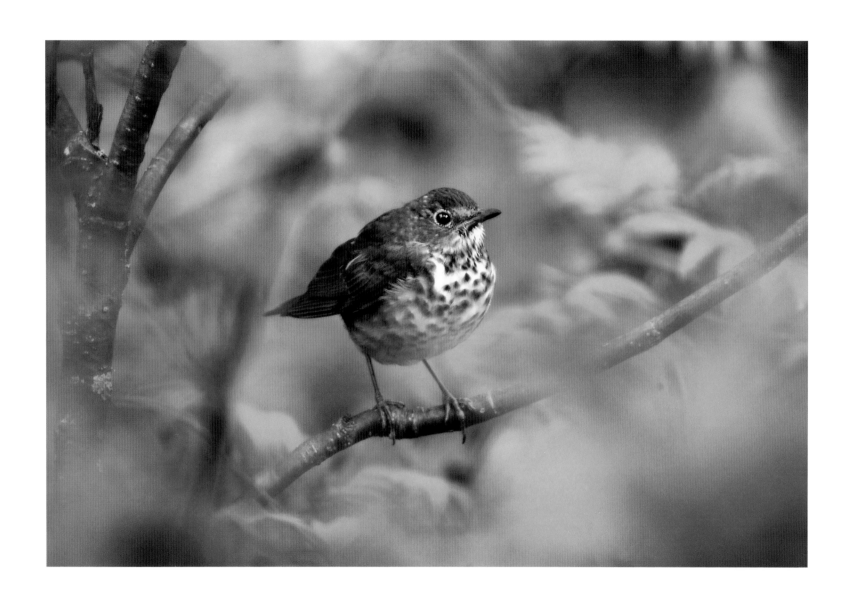

september DAY 83 eleven

10:07 am

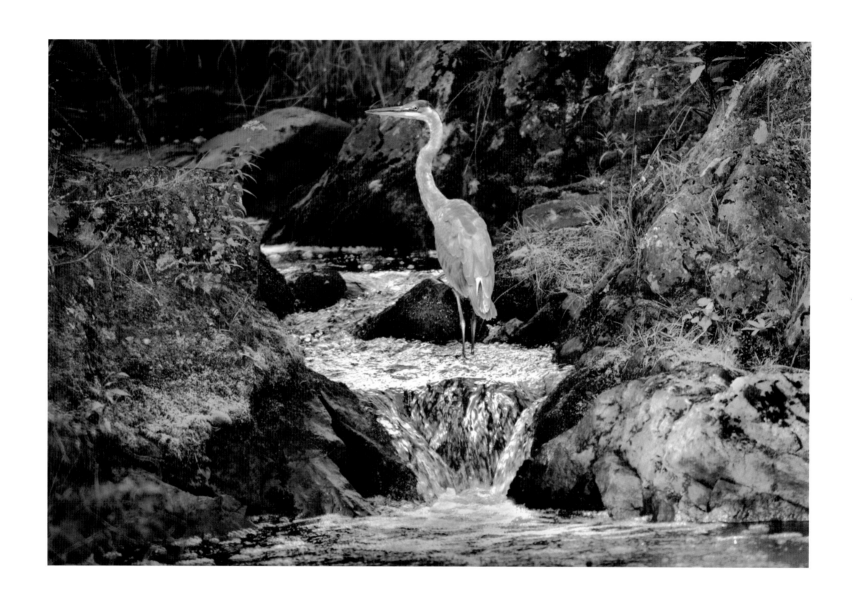

september <span>DAY 84</span> twelve

8:10 am

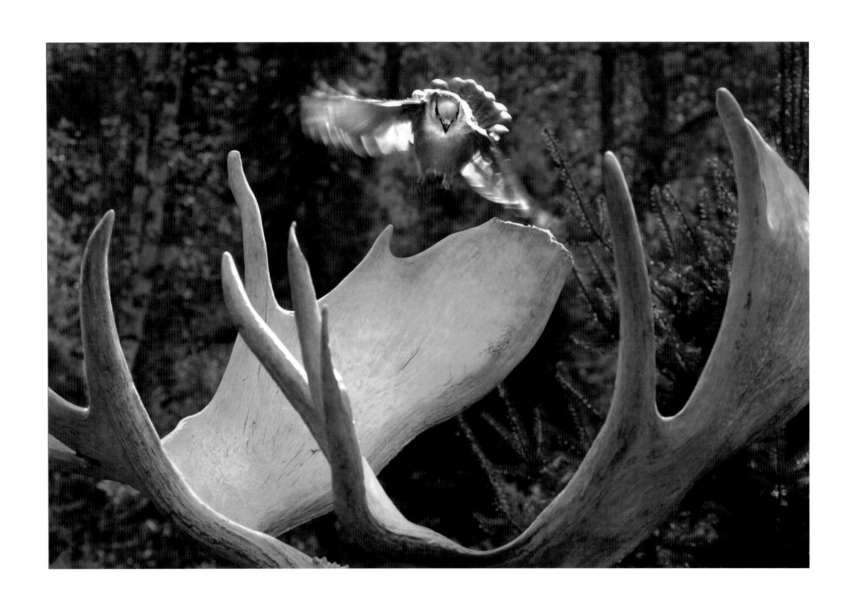

september thirteen

3 26 pm

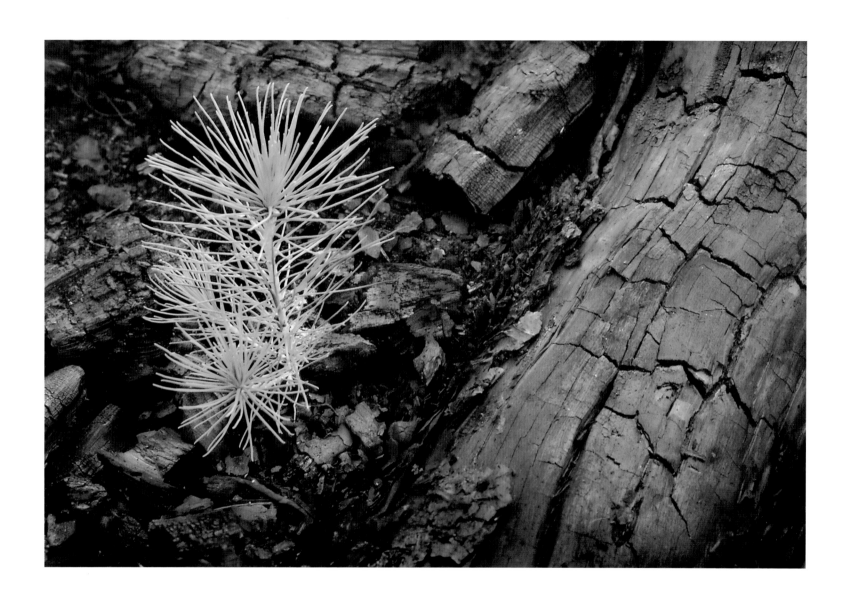

september DAY 86 fourteen

6 20 pm

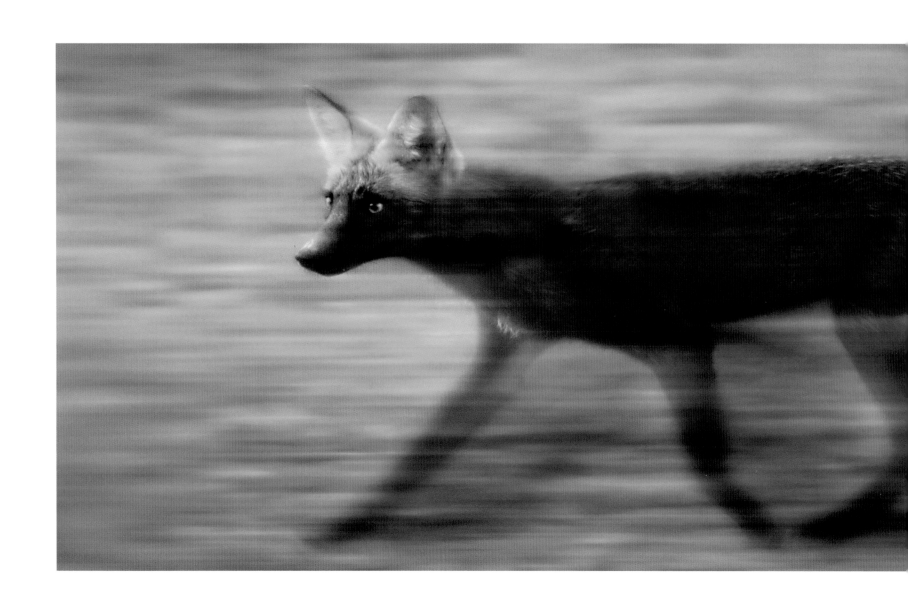

september DAY 87 fifteen

7:03 pm

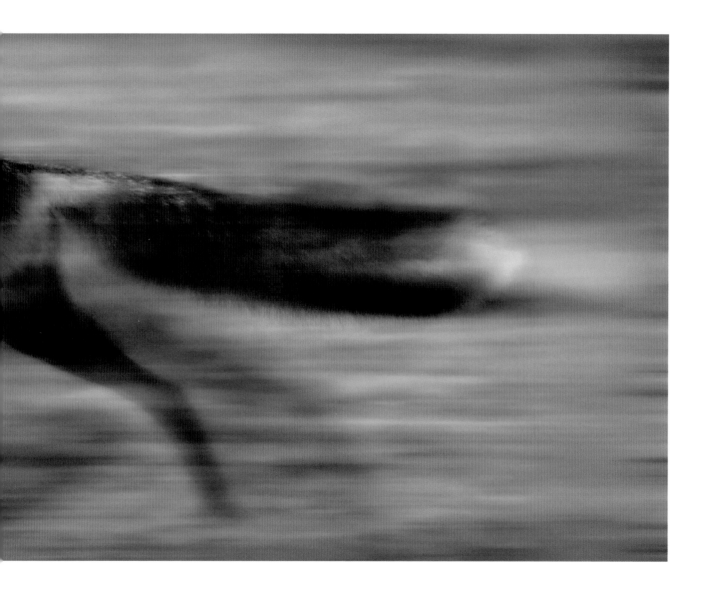

september DAY 88 sixteen

6 : 0 5 pm

september DAY/89 seventeen

7 01 pm

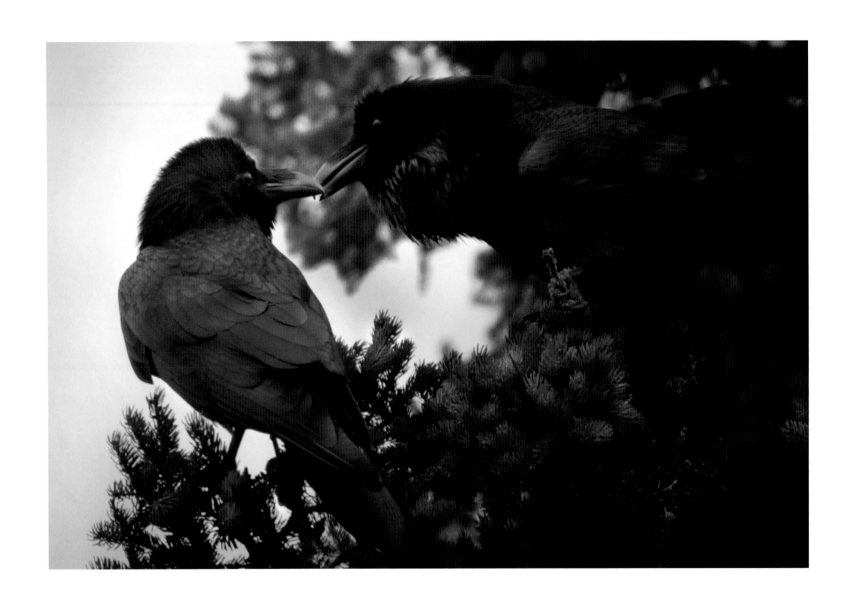

september eighteen DAY 90

10:37 am

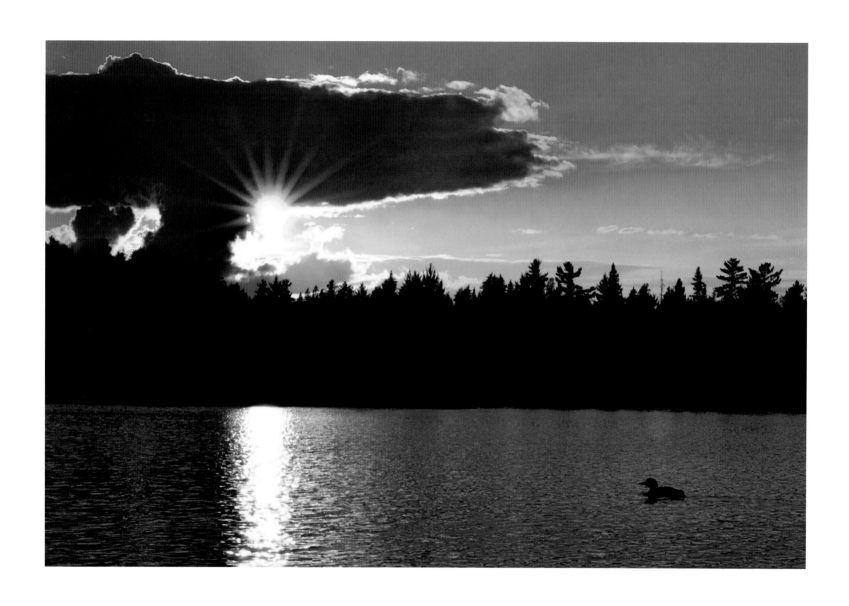

september DAY 91 nineteen

6:39 pm

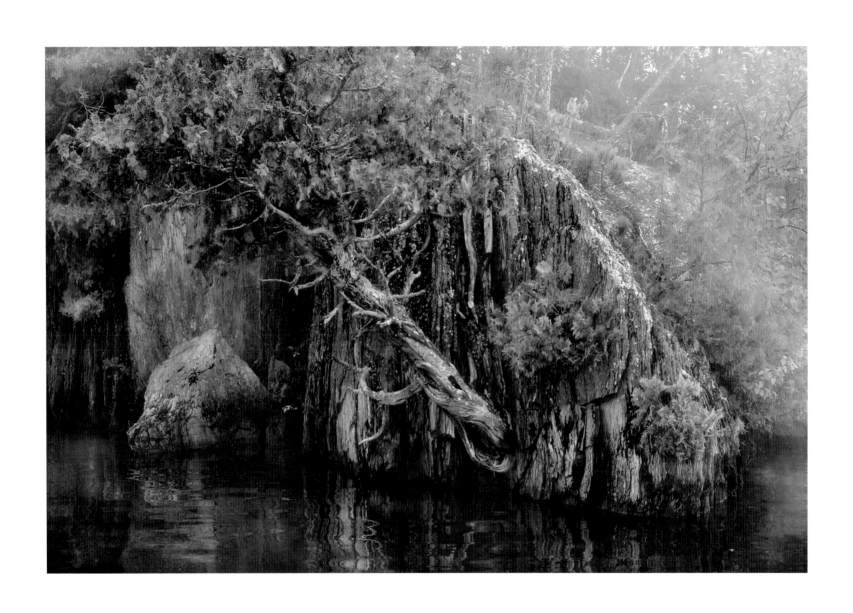

september twenty

8 : 58 am

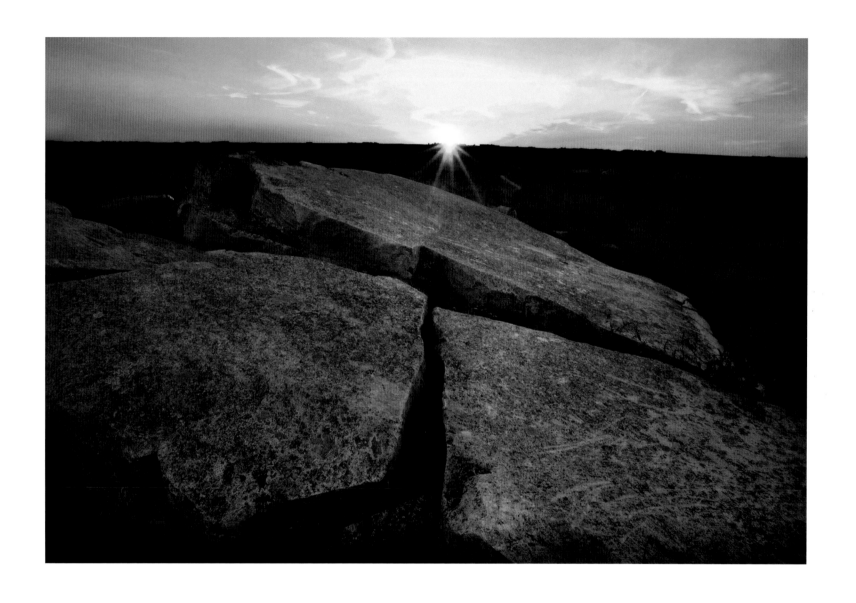

september DAY 93 twenty-one

9:20 am

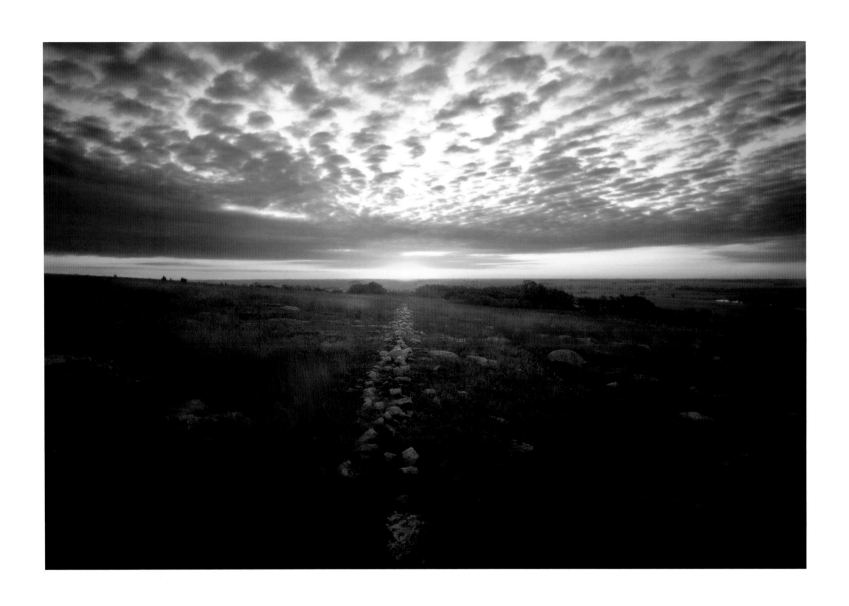

september twenty-two DAY 94

7:16 am

# LOOKING FOR THE SUMMER

THE STORIES

 DAY 1 The first hour of the first day on this summer journey handed me more tempting moments than I needed or deserved. From my backyard perch on the high cliff overlooking Olivia Pond I watched three anxious ducklings, in a brief but heavy downpour, paddle behind their worried mother. Soft backlight filtering through the rain from a break in a heavy cloud was all that was needed. I knew this would be the photograph of the day. Then, I met this enticing wild rose on the shore of Discovery Lake. Her soft deep pink flirted my camera in closer and closer until it couldn't focus anymore. Click! This beguiling cover girl set me with a mood that would last the next ninety-three days.     •     I've walked past these old-timers for twenty-five years now. Today I will again take some part of them back with me. Gazing on them with a DAY 2  lens deliberately fogged with my breath, I can't remember all of the cherished moments I've seen in their secret shade. For three hundred years—one hundred thousand days—they have lived quietly in this little valley, standing at attention while guarding this old animal path. There is something sacred about very old trees, especially this grove of great white cedars. Did the bear that marked the oldest by biting chunks of bark from its chest ask how many woodland caribou had passed by before they left this country forever?     •     It didn't take long for me to find and then get lost in a lakeside sedge DAY 3  meadow, my "woods prairie." This was the treeless landscape of my youth so it was only natural I stop

and pay homage early on in this project. Most of my time here on day three was spent making portraits of *Platanthera hyper-*

*borea*—tall northern green orchid. There must have been a hundred of these prolific yet modest looking orchids. But it was a sud-

den breeze off foggy Moose Lake that finally caught my attention.     •     This legendary land of the voyageurs is not easy to cap-

 DAY 4     ture on film—this surprises people. Vistas: those rare vantage spots along pathways, worn bare by the

boots of hurried visitors in their urge to carry home a landscape trophy in their cameras. They all seem to

recognize the same convenient "right spot," but most learn the bad news back home when the film comes back from processing.

Not far from my home there is such a place, and today I can't resist. My prairie eyes sometimes yearn for that occasional sunset

unfiltered by greedy trees.     •     I came here on the first day of my autumn *Chased by the Light* project. DAY 5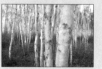

A black spruce forest always enchants me and I knew I would return. Once again, I thought I heard the

soft laughter from one of the "little people" hiding behind a tree along the moose trail. Walking along this ancient path in the late

purple light, I stopped and brought my camera to my eye. Yes! Finally happy with the day's conclusion, I slid my solo canoe across

the fragrant Labrador tea leaves near the shore and onto the calm surface of a secret bay.  I would be DAY 6

home in an hour, darkness racing me across the lake.     •     Not far from yesterday's shaded black spruce

forest, I'm in the totally different atmosphere of a white birch grove. The light, sounds and smells here are worlds apart. Did I travel a hundred miles? Blackburnian warblers, the orange and black feathered jewels in the bright branches above me, sing a very different tune than their cousin, the more drab Nashville warbler, found in the dark spruce boughs just down the Fernberg Trail. Many yesterdays back, the Ojibway's sleek birch bark canoes wore the stitched, taut skin of this lovely member of the tree tribe.    •

 We both have wet feet, but the wild blue iris prefers it that way. This was indeed a rare display—more than a thousand blossoms. I stayed just long enough for a brief taste; the table was set for a four-course meal but tonight the mosquitoes were doing the dining.    •    Does this young brown snowshoe hare know  why her feet are so large? And will she be surprised to magically float atop the deep January snowdrifts that she melts into with her new snow-white coat? The mysterious Canada lynx was born to solve that puzzle.    •

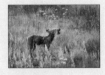 His five brothers and sisters are missing from his sight, and now this forlorn two-month-old wild timber wolf expresses his displeasure. Six adult pack members respond with a powerful howl that has been more misunderstood than any sound in nature. Although reassuring to a lonely wolf pup, this haunting and evocative song has caused much anxiety to grown men. Old wives' tales speak of wolves howling on the chase or at the kill, but I've never heard or seen this in thirty-five

years of living with and watching wolves. I expect it's a rare event. Wolves howl to find each other when separated from the pack or to

avoid conflict by reminding an adjacent pack not to invade their territory. I've frequently seen the pack howl just for the joy of it.    •

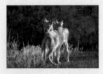  DAY 10   Like teenage boys, young packmates posture during a stand–off to decide who's boss of the playground.

This rendezvous site is where, over a period of several weeks, all the dramas of a growing family are

played out. Hierarchy is decided early on in a wolf family—their survival depends upon it. These two-month-old pups have a lot to

learn during their first summer. Six more months and the cruel reality of the "eat or be eaten" world comes into sharp focus. By the

time the first frost bites their unseasoned noses, the youngsters will be expected to help the adult members of the pack on the hunt.

It's a dangerous and demanding task to bring down a deer or moose. Half the pups will die by the first heavy snows of midwinter.

In fact, these healthy-looking youngsters disappeared with their four siblings and six adult pack members later in the year. I saw

them regularly for several months. Then, either they died, broke up or changed territory—probably a combination of factors. This pack

of twelve was part of an area that had the distinction of being one of the highest density wolf habitats in the world. That's a lot of

stress and competition. From what I know about wolves, the dynamics are easily changed under those   DAY 11

conditions. I have not seen them since. Alas, nature is a hanging judge.    •    "Trees are poems that the

earth writes upon the sky. We fell them down and turn them into paper that we may record our emptiness." Kahlil Gibran　　•

DAY
12　　"Peaceful, the gentle deer untroubled graze: All that they need, their forest-home supplies. No greed for

wealth nor envy clouds their days. But these are only beasts, and we are wise." Bhartrihari　　•

Ahh blueberries!  Twenty miles down the road is the little town of Ely, well known for its annual summer DAY
13

"Blueberry Festival"–the biggest event of the year. This week there are trillions near bursting in the forest

around me. Most will fall to the ground where they belong.　　•　　The showy lady's slipper *Cypripedium reginae* is our largest and

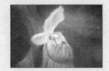DAY
14　　most spectacular native orchid, so it's not surprising that my home state of Minnesota gave it state flower

status. Although common in some areas of the north woods, this queen of orchids is apparently absent

in the million and a half acre Boundary Waters Canoe Area Wilderness that surrounds my home. How blessed I am, then, to have

one hundred and fifty plants blooming in my old cedar grove every July fourth. I find this show more spectacular than a fireworks

display. Digging up orchids for transplant back home is a sad mistake made by the unknowing public—wild orchids rarely

survive a move. Also, after the bloom, countless dust-sized seeds will float to the moss-covered forest floor, and seven-

teen years will then pass before a chance germination and flowering can take place. These are not very good odds—a fact

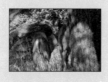 that adds to their specialness. • Friends for now on this pleasant summer day, this pair of alert whitetail bucks will go through a serious autumn transformation. Like the aspen leaves above them, their true color will change when the first frosts come. They may even find their regal newly grown antlers locked in battle as a flirtatious brown-eyed doe demands their attention. • Like a wind blown patch of tall-grass prairie, river grass waves

in slow motion in the Burntside River. Instead of birds, fish dart back and forth in the clear and steady current. • It's not the lovely blue-sky day that usually presents me with my favored images. Oftentimes a foggy sunrise or a thun-

 derstorm creates the right atmosphere and light. This is the first of several lucky encounters with the great blue heron during this project. • The camera sometimes sees things too literally for my liking. A birch grove photographed just before dark with a "rule"-breaking long handheld exposure is, to me, more "real" and

expressive than what a more literal interpretation might convey. "The eye sees only what the mind is prepared to comprehend." Henri Bergson • I travel to the north shore of Lake Superior to get a somewhat larger experience in nature.

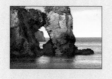  I love my backyard and the Boundary Waters, but the expansive horizon of the world's largest lake always inspires me as I gaze out onto an incomprehensible, ocean-like vastness. It's also like going back to an

old school. This is where I learned my craft. I was fortunate to live on the shore of the big lake for four years as a college student at the

University of Minnesota in Duluth. I enrolled in no photography courses, so this misty inland sea was my classroom and my teacher. She

taught me well. This arch at Tettegouche State Park is about ready to swallow a hungry beaver out for an evening swim. Does this tireless

engineer of the animal world dream of building a dam behind three quadrillion (fifteen zeros) gallons of water?     •     While editing

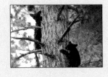 DAY 20 images shot during an encounter with a mother black bear with three cubs, I found it difficult to find a sharp

frame. A slow shutter speed could be blamed, but the probable cause was a little nervousness on my part.

I know black bears, except under extreme conditions, don't attack and eat photographers. The instinct to protect the triplets caused

the mother to send her cubs up a large red pine; she then mock charged me several times from twenty feet. Huffing loudly and snap-

ping her teeth, she certainly quickened my normally more deliberate shooting style. I don't like to stress animals so I left the scene

knowing I didn't quite make the photograph I had hoped for. My hurried and nervous state caused me to unconsciously abandon my

horizontal theme in shooting. This, as a result, is the only vertical photograph in the project.     •     Today I will spend the day in

my canoe looking for a calmer situation. Water reflections are a constantly changing and wonder-provok- DAY 21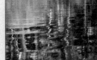

ing subject. I can photograph them for hours. The emphasis of my art studies in college was the French

Impressionistic period—I see that influence in this photograph. "La nature peint avec l'élan de sa force même, tandis que le peintre marie son imagination aux hésitations de sa main et de son esprit." (Nature paints with the momentum of its own force, whereas the painter marries his imagination to the hesitations of his hand and spirit.) E. Pallascio-Morin   •   The uncomforting noise of

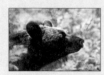

DAY
22

breaking glass at 5:00 am downstairs in the old cabin brought me out from a deep dream. A friend was staying over so I assumed he had carelessly dropped a trayful of dishes. Instead of my friend Jerry, I was greeted by papa bear intent upon stealing a fresh baked blueberry pie.  I should have known better and secured the kitchen window before going to bed. Blueberry pie smells as good to a bear as it does to me. The bear was more surprised than I as I shouted and clapped my hands. He made an immediate exit through the window he had just entered. One week later papa bear came back for a midday visit. I made his portrait while an angry and stubborn bee distracted him.   •   Fireweed is a lovely opportunist in the plant world. Fire has always been a frequent event in a forest, so it's only natural a plant

DAY
23

evolved to quickly pioneer in the newly burned forest. The lovely pink and fresh blossoms are a sharp contrast to the fiery event that made their bed. It's nature's way of giving hope to the future after our human-perceived loss.   •

The big country north of the border always pulls hard at me. It's only a few miles from here, but once that line is crossed the expe-

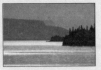

DAY 24

rience seems somehow wilder. While working on Lake Superior's Sibley Peninsula, I attempted to again show the drama of the Canadian wilds. Here in Sleeping Giant Provincial Park there is a piece of topography that, when viewed from miles away, appears to be a profile of a twenty-mile-long sleeping giant—napping for ten thousand years since the last glacier sculpted his form. Pointing a 500 mm lens towards home to the south, I made the exposure in the blue glow after the sun went beyond the horizon. I set up and shot from a position near the giant's ear. Even though he was fast asleep I wonder if he heard the quiet whispers with my elusive companion.     •     After a late nap, I swam

DAY 25

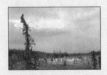

naked into the swirling silent fog of Marie Louise Lake, far enough out to lose sight of shore—how good it is to be swallowed up completely by a sleeping giant. A little fear heightened the experience.     •     Taiga—I've always liked the sound of this word. It's Russian for boreal forest, the largest biome in the world. The taiga is a belt of coniferous forest that rings

DAY 26

the globe and dips a little south from Canada into the U.S. here in the arrowhead of Minnesota. "Land of little sticks" is another description I've heard from the Inuit in the arctic far north—of course they are looking south to the tree line where a stunted boreal forest meets the arctic. Black spruce grows in a thick magic carpet of spongy moss where the thermometer reads below freezing half the year. I could start a glove museum from my collection of attempts over

the years to find the perfect solution for keeping my trigger finger warm while shooting pictures in this cold climate.   •

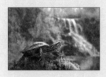  Winter was a distant memory, though, as I met this painted turtle basking in the balmy afternoon sun.

When aquatic creatures travel up Uncle Judd's Creek from Moose Lake, they eventually come to the

waterfall that plummets over the ledge outside my window. It's a good place to photograph the creatures as they stop at the pond

to puzzle their way around the barrier.   •   The black duck is a rare bird outside this area–it is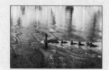

closely related to the much more common mallard. So much so that through inter-breeding the black duck

is slowly being absorbed into the more common mallard gene pool. Several times I've seen a mother black duck coax her newly

hatched brood over the waterfall on their way to the safety of Moose Lake. Once committed to the jump, the ducklings bounce like

tennis balls off the rocks on their way down the twenty-foot falls. It takes a lot of trust to take the leap without grown wings.   •

  Somehow it doesn't seem quite natural to find such a beautiful and delicious tropical-like morsel in the midst

of this often unforgiving northern land. My daily hikes take longer now as I graze the fruited forest trails.   •

My old friend the waterfall is where I turn when I need a "hug." Whether it's a calming that's needed or a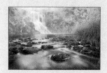

photograph that beckons, I'm never disappointed. At sunrise the cool air around the falls gives me a break

from the irritating mosquitoes that will drive me inside at midday.　•　The woodland caribou was once the predominant mem-

ber of the deer family in this border country. Logging of the old growth forests changed the habitat to the point

where the whitetail deer gradually took their place. The last animals were seen here around 1900. I need to trav-

el several hundred miles north into Ontario to photograph this favorite symbol of the old land. The only woodland caribou in Minnesota

today are living at the Minnesota Zoo, where I attempted to evoke the wild and elusive ghost image of this nearly forgotten animal. I know

the European cave paintings of Altamira and Lascaux have had a deep effect on me when I see images like this come out of my camera.

How much has art evolved in the thirty thousand years since? "None of us could paint like that." Picasso.　•　You won't find

Mystery Creek on the map. With so many unnamed streams in this wild country, I enjoy naming a few myself.　One day soon, I will

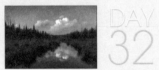

slip my canoe into this gentle highway and find where this mystery ends.　•　The bluets damselfly

is like a friendly heat-seeking missile programmed to strike the enemy—mosquitoes. I almost forgot that

mosquitoes do pollinate some of the fifteen species of native orchids growing here at Ravenwood. Trying

to keep track of the good guys and bad guys in nature is confusing.　•　Alien plants like the oxeye

daisy can seem more familiar to us than some of our native species. A happy and colorful face like that certainly is easy to be fond

DAY 34

of and I often pick bunches of them to cheer up my home. This pleasant tribe of blossoms had ancestors that came as stowaways on a boat from Europe over a hundred years ago. They since have taken over space where a fiddlehead fern or a wild columbine might have grown. Purists like me would prefer all native species to be prevalent in the scene. It sounds like a form of botanical racism. Nature study can be rather complicated. • I knew from the start this day would come. Everywhere I turned I saw an image that would be "the one." One of the most difficult parts of this process is editing out the culls. Today there were four photographs from which I couldn't decide. Even at this dead-

DAY 35

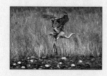

line stage I still can't choose. So here goes...the loon pair. Loons are such a symbol of this boundary waters I decided this close-up portrait needed to be included. There were several nice portraits of wolf pups that tolerated my company earlier that day, but I had already chosen a couple of frames of that pack for days 9 and 10. It is certainly a blessing to be forced to choose between such grand animals. • During a pleasant noontime paddle with my daughter, I made an uncommon midday photograph of this great blue heron. Shooting in the harsh light in the middle of the day is something I normally try to

DAY 36

avoid. As Heidi paddled slowly and carefully toward the alert and suspicious bird, I slowly raised my camera and waited for it to gracefully take flight. • The monarch butterfly is one of those creatures

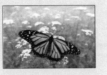

DAY
37

that truly goes beyond our understanding. Bird migration is still a puzzle, but an insect with a much smaller and simpler brain takes the mystery of migration to a higher level. How can a great-great-grand-child of a monarch that over-wintered in a fir tree in central Mexico know the route back from Minnesota? Atop the three thousand miles of speeding cars, children with butterfly nets and bad weather, they must find the exact same tree. Amazing. I thought my GPS was impressive.   •   A heavy and dark falling sky did indeed reflect my experience on the edge of this small quiet lake deep in the Superior National Forest. While searching out a good vantage point to frame a shot, I climbed

DAY
38

out on a fallen trunk of a decaying black spruce that hung out over the water. Inching towards the spot I needed to make the photograph brought me out a bit too far and a little too high. Just after clicking the shutter the tree broke, send-ing me spread-eagled on top of another broken spruce sticking out of the water, the jagged four-inch stump nearly impaling me in the chest, just over my heart. When I regained consciousness I didn't expect to make it back to civilization. Only a couple of times in my far-flung exotic travels have I sensed this kind of doom. The most interesting thing about the experience, now that I look back, is the name of that memorable place—Heart Lake.   •   "In nature a repulsive caterpillar turns into a lovely butterfly. But with human beings it's the other way around: a lovely butterfly turns into a repulsive caterpillar." Anton Chekhov.  I have no quarrel with

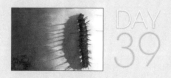

DAY 39 the genius Chekhov, and although I think I know what he was getting at, should all people be painted with such a heavy color? The innocence of animals and people is a relative notion. For me, the wild creatures can do no wrong. • I had a wonderful surprise since making the photograph of this bold bouquet of fireweed. A friend liv-

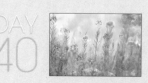

DAY 40 ing in Alaska recently sent me a container of syrup made from the crushed, sweet blossoms of this pio-

neer in the plant world. It tasted great on pancakes. The indigenous people also saw value in this plant

and used it as a medicinal for the treatment of bruises; I certainly could have used this treatment after my mishap at Heart Lake a

couple of days back. • "Like water off a duck's back" the old saying goes, to describe the ability of not allowing oneself to

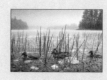

DAY 41 be troubled by an irritant. Standing up to my knees in Lake One during a downpour—lightning flashing all

around—caused me to consider my vulnerability and the old saying. It was clear to me who was most at

home here. The black ducks and the lilies looked so "right" in the rain. My camera and I didn't fare as well. • Every so often

a sunset here in the boreal forest rivals the spectacular shows I grew up with on the prairie. "Like winds and sunsets, wild things

were taken for granted until progress began to do away with them. Now we face the question whether a

DAY 42 still higher 'standard of living' is worth its cost in things natural, wild and free. For us the minority, the

opportunity to see geese is more important than television, and the chance to find a pasque flower is a right as inalienable as free

speech." Aldo Leopold   •   After a midsummer downpour, the falls on nearby Judd Creek rise to a level of sound that can

 almost become annoying after a few days. The house vibrates a little and I miss the silence that defines

living in such a remote location. Why would one complain of something so wild and beautiful?   •

This may be one of those occasions when the camera reveals more than what the eye can see. It was nearly dark, almost black,

when I decided to push my camera to its limits. Resting the camera on its tripod I squeezed off several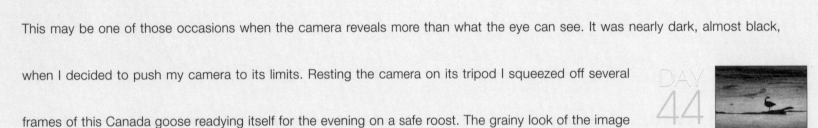

frames of this Canada goose readying itself for the evening on a safe roost. The grainy look of the image

is the result of my dialing in the highest speed of the digital receptor, 3200. I normally set the camera at 100. The effect has a pleas-

ant, almost impressionistic feel.   •   Within this stretch of ninety-four days of summer, I needed to make two trips out of the

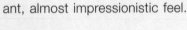 north woods and onto the prairie. One of my favorite plants from the grasslands is the purple coneflower.

Echinacea, the popular herbal cold remedy, is extracted from its roots.   •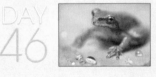

The chorus of thousands of tree frogs in the evening hours is one of nature's most mesmerizing sounds.

To think that every one of them is a lovesick male saying, "I love you" to a pretty little lady tree frog makes me smile.   •

DAY 47 This is a day of celebration. It marks the halfway point in this ninety-four-day journey through summer. I feel exhilarated because unlike the ninety days of autumn of the *Chased by the Light* project, I have many more daylight hours to photograph with a more dynamic texture of life forms in this explosive growing season. It is difficult to limit the possibilities before me.    •    I would like to think of myself as a serious photographer and that my work is admired by my colleagues and peers. Humor has a place in this world but I've never intentionally tried to portray or use it in

DAY 48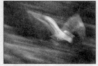

my main body of work. An occasional "off" moment snapshot that makes me smile might find a place in my second-level select files. This sounds rather self-important, but some of my type actually think we can have an affect on the world with our pictures, so only serious statements need apply. This moment was one of those casual efforts, shot without much thought. I don't know if it was something I finally saw or the numerous comments from my friends that made me keep it in the finals. Perhaps the diminutive red squirrel defending its big tree home says more than another "important" photograph.    •    The elegant great blue heron visits my

DAY 49 camera once again. "Hold fast to dreams, For if dreams die, Life is a broken-winged bird, That cannot fly." Langston Hughes    •    One of my favorite slogans in the environmental movement is, "Dream back the bison, sing back the swan." These trumpeter swans came close to extinction this century and now it appears they are safe

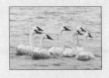

from that far-off dark place beyond infinity. I'm glad that we had a beautiful song for them in the name of hard-working and dedicated two-leggeds. My first day back on another excursion to the wind-blown prairie gifted me with this suspicious flotilla.     •     How many songs and poems have been written about the butterfly? This east-

ern swallowtail rested in a field of prairie flowers that grew at the foot of a forty-foot cliff a stone's throw

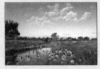

from my mother Olga's childhood home. As a boy I heard her stories about this wonderful playground of caves and secret hiding places. I recall her telling of one narrow slice in the Sioux quartzite: she and her ten Norwegian siblings named it "Fat Man's Misery." When I grew old enough to explore on my own I traced her path; now there would be added stories and newly discovered places for me to tell my children about. On and on it goes. A century and a half earlier the Sioux stampeded bison over this escarpment and butchered them on this very spot. Oh, how I wished I could have also listened to the stories told by those elders. Buffalo blood and bones became dirt became sap became butterfly became photograph became me became you.     •

Some of my first memories of wild nature are from the banks of the Rock River, but yellow coneflowers and big bluestem prairie

grass weren't growing here then. I well remember walking on the over-grazed cow pasture that resem-

bled a heavily played golf course. Almost fifty years have passed and the river has now changed its path.

I fondly recall the day I nearly stepped on a several-hundred-year-old bison skull freshly exposed by the river's new course. The prized artifact was almost too heavy for my young frame to carry the two miles back home. The old skull sits across the room from me now and gazes at me with a hollow look as I reminisce of those early learning days. Such dramatic evolution of the land should make me feel old, yes a little, but I am more uplifted to see the native prairie coming back with such splendor. Someone has since cared well for this land on the bend of the little river called Rock.   •   While visiting Blue Mounds State Park near my home-

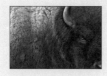

DAY 53

town of Luverne in southwestern Minnesota, I am drawn to a descendent of the owner of that buffalo skull that still speaks with such an angry, haunting stare. This grand symbol of the prairie almost became a "dream" when their numbers went from millions to less than two hundred during the European settlement of the prairie. My great-grandfather, Henry Brandenburg, just may have seen the last wild bison in Rock County.   •   The cuckoo was

an exotic encounter for me—I don't remember seeing one here until recently.  As habitats and climate

DAY 54

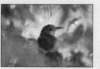

change, this bird, along with several other species like the opossum, have made a shift north from their

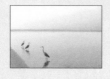

DAY 55

traditional territory.   •   Returning to my home in the north woods from the prairie, I stopped to visit a place on Lake Superior where I had previously lived.  Walking along the familiar beach line of Park Point,

I was met by three great blue herons migrating from the distant northern horizon and it was clear they had been on a very long flight.

Once they reached terra firma they landed and folded their wings just a few feet in front of me. Never have I seen the great blues

ignore me like this. The exhausted trio may have flown nonstop several hundred miles; this time they would allow me to do their

portrait from a few feet with a wide-angle lens.    •    Standing in a heavy downpour on the shore of a wilderness lake is an exhil-

 DAY 56    arating experience. Getting soaked on a city street corner is something else. "In one drop of water are

found all the secrets of all the oceans." Kahlil Gibran.    •    A short walk down a path from my home,

there is a place I go to watch the comings and goings of the tireless residents in a beaver colony. I call it DAY 57

Beaver Valley, because of its wide grass and sedge meadow that lies between two high ridges. It's one of

the places where I feel particularly inspired here at Ravenwood. Everyone has a place where they go to transform themselves. I try

to analyze what causes such good feelings in a place like this—is it the pleasant composition of elements that we see or an unseen

ambiance that we will never identify? Maybe it's genetic memory that takes us all the way back to Africa where we evolved on the

savanna with its wide open grassy areas punctuated by the trees we climbed down from so long ago.    •    Today, a piece of

canvas came floating my way that had been cut from the larger and more complex painting that Mother Nature puts down in front

of us. Non-literal abstract shapes drawn from nature are magical and genius to some, but random, unclear childlike scribbling to others. The debate is old. "What is good art—shouldn't it look like something?" The greatest artists moved from the photographic, realistic-type depictions to the more unrecognizable forms. Should I be complimented or offended when one shares with me, "This photograph looks just like a painting"?     •     Other than the sun, clouds are the most familiar shape worldwide. The land reveals its unique fingerprints as one moves from one continent to

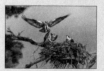

another. From deep dark jungles to bright white and featureless deserts, each has its own memorable qualities. Endless in form and shape, the cloud is so familiar to us that it is one of the most universally comforting sights in all of nature. I can't think of a view that provokes more daydreams.     •     As a boy I observed the serenity and persistence of the spider—

unattainable for me, I thought. Nearly a lifetime later, I still strive for that elusive and hard earned quality. "Adopt the pace of Nature, her secret is patience." Ralph Waldo Emerson          •          The bald eagle has a grandeur that is befitting of a national symbol, but the osprey, the other large bird of prey here, always warms my soul. Maybe it's because of its impressive gymnastics in capturing dinner. It spots a vulnerable fish while soaring, then sky-

dives to impale it with specialized talons. I've often watched an osprey collect itself after the dramatic plunge

by floating with wings outstretched while maneuvering to quiet the fish beneath the surface. Once it awkwardly flaps itself away

from the clinging water, the prize is positioned to behave as aerodynamically as a torpedo held on the belly of sub-hunting war-

plane. Every summer I'm relieved to see this old snag white pine still barely holding on to its precious cargo.    •    I have often

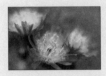 wondered how this flower was named. I looked it up to find the Greeks believed raptors ingested its sap

to acquire their keen eyesight. Imagine: one nice summer day in ancient Greece a birder thought he saw

this happen or came up with the notion. He passed the story on to a believing friend. Two thousand years later that misguided

impression is still with us in its name—Hawkweed.    •    I photographed this fallen "grandmother log"

in the previous *Chased by the Light* project. This time, instead of moving my camera during the exposure

(I was attempting to create a mysterious look to the image to mirror the mystery that surrounds this old grove of cedars) I walked into

the camera's view and inserted myself briefly into the frame as the shutter recorded a ten second exposure. "Meet My Psychiatrist"

was my title then—I still have the same relationship with my old friend today. "See how nature—trees, flowers, grass—grows in silence;

see the stars, the moon and the sun, how they move in silence…we need silence to be able to touch souls." Mother Teresa    •

How did ancient man explain the moon with its ever-changing shapes as it tracked against the black canvas of an evening sky?

 DAY 64 Modern man knows a thousand facts about the celestial bodies but I often wonder during an electric lit night how much we have forgotten about an older and perhaps more powerful story. •

"Touch me not." Just another one of those names that makes you wonder why it is named the way it is, until you see for yourself.

Of course the timing needs to be right, but to see how a plant has developed an active mechanical strategy  DAY 65  to improve and secure a place on this earth is remarkable. When the time comes to drop its seeds, a simple

touch or brushing of an animal causes the seedpod to snap and propel seeds out into a new location away from the mother plant.

• It's an old and familiar question for those of us who choose to live in the north. They ask, "How can you stand to live in such a cold

 DAY 66 climate?" We laugh and talk of all the wonderful reasons, knowing all the while it isn't convincing and doesn't quite

translate. Then one day comes the first hint of "that terrible time." It is still summer but most everyone I know

around here talks with giddy excitement about the first fall leaves and whether we will have a beautiful show in the woods the coming fall. •

It's the rain that fills the sparkling lakes near Ravenwood—they are some of the cleanest in the country and I often drink from

them directly. Beavers are the biggest problem. They harbor a parasite that's not fun to take on; I've  DAY 67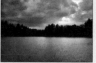

had giardia a few times myself. Drink from a canoe out in the middle of the lake is the local advice. •

A miniature mushroom forest conceals many mysteries and secrets beyond what is evident. A taste of this tribe of complex plants can

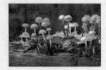 send one to many places. At once a gourmet's delight or a death sentence, a bite of some varieties will send

a mind traveler on a hallucinogenic journey to worlds never imagined. Europeans generally place a higher value

on collecting wild mushrooms for culinary treats than Americans. The *Xeromphalina campanalina* pictured here is known on both continents

but is too small to be bothered with. In fact there is no data as to whether one can even take a "trip" with this variety commonly called

fuzzy foot. While on a National Geographic assignment in Russia I became aware of the cultural attachment of the mushroom. My nerv-

ous KGB (Cold War era) baby-sitter abandoned me in an autumn forest northeast of Moscow. Although we were on a tight and inflexible

schedule, Victor decided the woods we were traveling through were worth the delay for a mushroom search. "I used to do this as a boy

with my family," he yelled as he left on his quest. The memory of the joy of mushroom hunting was still a powerful pull on him even though

it was clear it had been years since he had been alone in nature. Hours later, he returned with his shirt-basket overflowing with delectable

ivory white mushrooms. He was changed man. Nature is a great healer.     •     Painted turtles are numerous in the thirty-acre Judd

Lake where I keep my bush camp. I've seen their protective shells gouged and scratched, evidence of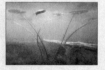

some frustrated predator like a fox or a wolf trying to gain entrance to the prize. They are usually safe from

hungry creatures after they reach a size that is too large to swallow whole. This one will spend the winter nestled in the mud on the

bottom of the lake, but summer is the time for swimming lazily through the forests of lilies.    •    This day passed a little too fast

for me. With all that goes on in the forest during a summer day, one would think I could certainly decide on a subject and capture

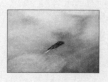 DAY 70    an image that would please everyone. There are days, though, when the rhythm or mood doesn't allow

that elusive creative channel to open. I need to be pleased when I trip the shutter or this self-assigned

process doesn't work. The whole day was spent and now was the last bit of blue light lingering. The sun had already set sometime

ago and it was now too dark to photograph in the woods, so I moved to the lakeshore where the light had a better quality. The leop-

ard frogs were posing nicely when this raven feather caught my eye. I thought it was the perfect situation to sum up the day. My

mood was captured.    •    A thousand years of rolling up and down the shore of the mighty Lake DAY 71

Superior has shaped this collection of rocks to the perfect size and smoothness to stick in your pocket

and save for a good rub. I've solved more than one problem while polishing one of those little nuggets.    •    Time is a quality

in which humans have a self-centered perspective. Now invisible to our impatient eyes, Gem Lake is slowly disappearing. Not in a

year or even a hundred, but slowly the shore is growing toward the center. As I worked my way to the water's edge to make this

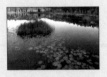

image, the ground beneath my feet started to undulate and quake. The tops of the black spruce trees

around me bowed my way at every step. I was now standing on a thin floating mat of bog vegetation, with

the possibility that my camera and I would slice through and get a cold dunking in several feet of water. My tripod was worthless

now on this wet and wobbly platform. I was lucky to get a sharp exposure in the fading light.     •     I'm back to the shrinking

Gem Lake on this morning. I nearly stepped on this delicate little rose pogonia (*Pogonia ophioglossoides*) last night while swaying

to keep my balance. This first day of September is a very late date for a delicate orchid to be in full bloom

at this latitude, so I was excited and relieved to have my assignment decided for the day. As soon as I

saw the orchid (my first sighting) I knew this was how I would represent the day. The first hard frost of the season was due any day,

so now was the time. Plus, I have a kind of affection for one of the last blooms of the summer. Lying on my stomach to meet the

blossom eye to eye was very uncomfortable—it felt as though I was floating in a leaking waterbed that was in motion. I brought the

thumbnail-sized flower into focus just as the first annoying morning mosquitoes discovered me. I'm always surprised at the difficul-

ties of performing the exacting business of close-up photography while under attack from these dive-bombers. Now was the time

to go. There was a frost in the low areas next morning.     •     The canoe country has a colorful history. French voyageurs pad-

DAY 74

dled this river called Vermilion in the mid-1600s and were no doubt aggravated when they were forced to portage their heavy birch bark canoes and Indian trade cargo around these Vermilion Falls. What is irritation to one is delight to another. Today, visitors to the Voyageurs National Park area are drawn to these falls and find themselves mesmerized, then bored, as they search for yet another prize vista on their summer holiday—I'm guilty of doing this myself. •

At first glance, this photograph has a midday look to it. But in fact the noon sun was at that moment shining down on Calcutta. It was midnight for me. The full moon was my only light source. I was impressed by my new digital camera's ability to render the scene with such accuracy. Traditional film would not have given me such an unbiased look at this valley under these conditions. •

DAY 75

It's a dramatic sight when I paddle into a quiet bay that is covered with

DAY 76

thousands of exquisite white water lily blossoms. It's always a good place to encounter wildlife, in these shallow wild gardens. I've seen a homely cow moose dining on a lily salad alongside a beaver munching on the plant's nutritious root. • Red pine bark has a striking quality that has always attracted me. I enjoy getting lost in the shapes and textures on the skin of this magnificent conifer. But there is a more important function. The bark of mature trees like

DAY 77

this centenarian repels fire. It is ironic for a red pine stand to benefit from an occasional low intensity fire. •

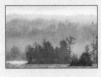

DAY 78

I'm continually searching for that archetypal image of the Boundary Waters. It is not easy to capture one image that sums up this expansive wilderness. This is grand country and it is my home, so there are many opportunities, but I can count on one hand the frames in my collection that achieve this goal. I was pleased the editors of National Geographic Magazine chose this panorama of the not-so-wild Shagawa Lake, on the shore of my hometown Ely, as the opening foldout in their adaptation of this project. • The broad-wing hawk has a call that has become a standard, almost stereo-

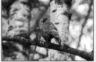

DAY 79

typic, sound in movie and television sound tracks that want to portray a wild setting. With the coming autumn, the hawk clan will soon migrate from their northern summer home. Hawk Ridge, on the north shore of Lake Superior, is legendary for the numbers of sightings of these birds of prey. In 1993, on one September day, 47,922 broad-wings were counted soaring above the high ridges along the big lake on their way south. • This tip of rocky penin-

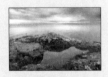

DAY 80

sula that penetrates into the cold environment of Lake Superior speaks to the influence of this huge body of water and how a mini ecosystem can develop. The make-up of plants here reflects an arctic setting normally found a thousand miles to the north of this latitude. • The Baptism River winds its way down from the gentle wood-ed slopes of the interior of the Superior National Forest into the hills overlooking the mother of all lakes. The river then takes a dra-

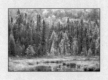

DAY 81 matic plunge the last mile and empties into Lake Superior. Two hundred years ago French missionaries used the large pool at this meeting point to baptize the local Indians—the name stuck.     •

"God Light" is what my colleagues call this dramatic effect when the sun breaks through a dark cloud to spotlight a feature of the landscape. I've stood on the shore of Section Twelve Lake many times, knowing all the elements were not DAY 82 quite present to make a respectable picture. Surprisingly, it is often the quality of the light, not the subject itself, that makes or breaks a photograph.     •     This morning I heard the bad news of 9/11. After some solemn contemplation, I gathered my equipment to look for a non-challenging image. I would shoot the first subject that presented itself, DAY 83 not being in much of a mood for happy woods wandering. Just outside the door, the sight of this innocent Swainson's thrush took me away from the overwhelming weight of the world's problems.

"Po po tu tu tureel tureel tiree tree tree" so goes its song—at least according to my latest bird identification book. Something is lost in the translation, though. When evening's blue-gray dusk quiets most of the forest, the liquid voice of this elusive cousin of the robin closes out the day with a most beautiful melody—one of my favorites. Sadly, later in the day I found it lying dead beneath my studio window where it had crashed—a extraordinary conclusion to an already strange day.     •

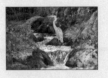

**DAY 84**

Every now and then I'm able to carefully open my window from the comfort of my home and capture an image that resembles one that I might have made in the deep wilderness. The animals have grown accustomed to the structure, so I am able to shoot rather shy animals like the timber wolf. Even the great blue heron is often too difficult to approach this close here on Uncle Judd's Creek.     •     The gray jay has the likable and predictable habit of seeking out and begging, sometimes stealing, food from humans and I have often felt the reason is because they have

**DAY 85**

practiced this behavior through the ages. Native Americans may have been a tolerant if not benevolent partner here for thousands of years. I have been greeted by this feathered friend in such remote areas that I felt I was the only human visitor for months—if ever. This common and universal pattern of unusual fearlessness toward humans appears genetic. This set of moose antlers is all that remains of a wolf kill from a couple of years back. Always on the lookout for scraps, the bird was drawn to the rack because of my nearby presence. When a wild animal naturally and without fear greets me, it brings a smile and often a tasty reward for my companion also known as the "camp robber."     •     The boreal forest's prevalent jack pine exhibits a near

**DAY 86**

total dependence on fire. This seedling was born from a blaze that seared open a tightly sealed cone from the mother tree. When opened, the cones release thousands of tiny black seeds that fall to the newly

enriched, sunlight-drenched soil. Fire is at times difficult for a self-focused two-legged to tolerate and understand, but nature in her

own way always has a larger and wiser view.　　•　　Silver fox—just the name conjured up romance and mystery to me as a wilder-

 ness-starved boy growing up on the landscape of the prairie, dominated by cornfields. The red fox was my

DAY 87

champion animal and was common in those parts. Little did I know these two were really the same animal.

On the prairie, I saw only the red phase, but in the north woods, a vixen may give birth to a litter of pups that range from silver through

red to faded yellow. It took me forty years to satisfy my pursuit of a silver fox in this photograph at dusk near Burntside Lake.　　•

Autumn is giving a louder signal now and the pace is quickening; soon another round of tourists

DAY 88

will arrive. Summer clearly is in the past tense. The nights are freezing but that's not the main

reason for the foliage color change. The scientific explanations of how and why leaves change color are full of big words

and complex formulas: Photoperiodism, $H_2O+CO_2 \rightarrow CH_2O+O_2$. Most people don't care about that—they just want to

see and take a picture of the pretty leaves. Me too. I know my project is coming to an end, and I have an anxiety that

feels as though I am out of breath and can't catch up. I can see the autumn pace in some of my animal neighbors.

Like the bear, I need to finish gathering before I can retire this seasonal diary and stop looking for the summer.　　•

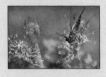

The struggle to survive is a common theme throughout nature. There is drama of the greatest proportion (especially for the victim) being played out quietly and sometimes not so quietly on all scales and at all hours of the day and night. The most dramatic may have a pack of a dozen sharp-toothed timber wolves noisily taking down a twelve hundred-pound, desperate moose. Then, we find a plant killing and eating an animal. The sticky and hungry sundew silently entraps, then digests, a mosquito that an hour ago was sucking blood from the erect radar ears of the bold leader of the wolf pack. Over time, too much time for humans to comprehend, nature balances trillions of factors to achieve a miraculous equilibrium.  •

"Till death do us part." I have great admiration for the wolf, but I believe the raven has an ability to perceive and function in its environment like no other animal. This raven couple will court throughout the year

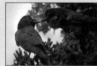

to keep their bond strong. They mate for life. My summer project would not be complete without a portrait of my friend raven.  •

Lakes are so numerous here in the Boundary Waters that surveyors and other early settlers must have occasionally depleted their usual stock of names of wives, mothers and admired friends. Every lake, of course, had an Indian name, and the settlers used them when

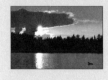

they could be pronounced and remembered—most are forgotten now. This Lake One sunset with a loon is in a string of lakes with Lake Two, Three and Four. It must have been a very tiring day indeed for the map-

ping crews to have no better names in their repertoire. It speaks of how casually this magnificent country was taken a hundred years ago. On a better day, nearby lakes like Alice, Isabella, Polly, Hazel and Thomas still carry the names of otherwise dead and forgotten relationships. One name that is conspicuous in its absence from the list is Sig Olson—who, more than anyone, worked to preserve this treasured canoe country. Before Sig died, old and wise, in 1982, I was fortunate to spend time with him walking these woods and paddling these lakes. Someday before I die I will find a nameless lake and fill that blank spot on the map with his name.      •

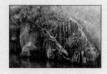

DAY
92

Even though the twisted trunk of this old survivor isn't much bigger than my leg, this cliff dwelling eastern white cedar is several hundred years old. Ojibways, then French voyageurs cruised past it in birch bark canoes stroking along with their white cedar paddles. Thousands of wilderness lovers now follow in their wake—today a joyful and healing adventure, yesterday a serious day-to-day endeavor of pure survival.      •      The plan was to finish this mission on the land I was born. I would leave my wilderness home and travel the five hundred miles back to a special

DAY
93

place within a mile of the little prairie farm of my youth. Migrating birds accompanied me south as I left the shade of the trees to come out upon the bright open plains. Like a salmon coming back to the nursery stream from which it hatched, I instinctively felt the need to witness the autumnal equinox on the sacred ground we named Touch the Sky Prairie. High

above the surrounding farmland I stood on this virgin prairie overlooking the playground of my early years. It was saved from the

hungry plows of a hundred years ago by scattered Sioux quartzite bedrock humps polished smooth by the last glacier. Pink car-

sized boulders had their corners polished to a mirror finish by great herds of bison meeting on this breezy ridge. For ten thousand

years they came to gratify their itch. My great-grandfather sharpened his plow two miles south of here and they tell me the roots of

the prairie plants popped when he finally persuaded his two stubborn oxen to pull that plow through the virgin sod. I guess he was

good at that; he also persuaded his stubborn wife and six sons to leave a comfortable Brandenburg clan in Germany to live in a dirty

sod house on the American prairie wilderness. That's where I pick up the story—my blood was a partner in the design that swal-

lowed 99% of our largest ecosystem. This placid landscape surrendered so quickly that little cataloging of its inhabitants was com-

pleted before it disappeared. Three hundred fifty species of grasses and flowers grew on an acre then. Now only one species per

acre thrives—corn or soybeans—if the industrious farmer triumphs with his chemical weapons to kill this second wave of European

immigrants—the dreaded weeds. The other side of the coin: it's the breadbasket of the world. Now a partnership has been estab-

lished to save the last long grass remnants in Rock (pink boulders) County. I, along with Chamber of Commerce classmates from

the sixties, persuaded the U.S. Fish and Wildlife Service to be our partners. Eight hundred acres of restored prairie has become one

of the nation's newest preserves—Touch the Sky Prairie National Wildlife Refuge. I am more proud of this than any award I have ever

received and I am pleased my photography can do more than simply adorn magazines and books.      •      Yesterday's sunset on

the last day of summer technically should have been the last image for this project. But when I positioned my ninety days of autumn,

 DAY 94 *Chased by the Light* next to *Looking for the Summer's* ninety-three days, one day came up missing. The

two projects were photographed in different years, so with our imperfect calendar system, a day disap-

peared. Eventually I will complete the year by photographing every day of the other two seasons—winter and spring—and so I find it

necessary to add a day to summer. The location I selected to fill this void was ground that had deep meaning in my life. Touch the

Sky Prairie is within walking distance of a human-built stone structure at Blue Mounds State Park that teases our imagination twice

each year. Today's autumnal equinox sunrise and the vernal equinox in six months are both in alignment with this puzzle that defies

explanation. Scientists can't prove or disprove its origins. That leaves romantics like me to suggest Native Americans used it as a

celestial-based ritual site. There are several reasons too long here to explore why I feel this may be true. That was inspiration enough

for me to come to this place on a day of calendar confusion. But there was another and more personally compelling reason. At age

fifteen I had a revelation here—I discovered the magic and mystery of capturing the likeness of a wild animal with a camera. As I

shared on day 87, the fox was a special creature to me when I was a boy, but it was nearly impossible with my young and clumsy

ways to approach them. Over forty years ago, I had found a small plastic Argus camera on the closeout table at the drugstore.

Three dollars for the camera and roll of Kodak 828 film—I now was ready to take on the world. Armed with great hope and expec-

tations, I headed for my local wilderness—the Mounds. Nearing the alignment I spotted my respected teacher, the fox. I knew a

squeaking rodent could attract a predator, so I hid behind a quartzite boulder and became a mouse, irresistible to my quarry. It trot-

ted straight to the easy meal by the boulder. I carefully peeked over the top and found myself face to face with my future.

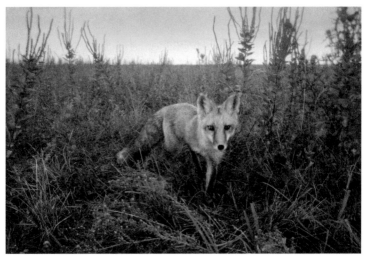

FIRST WILDLIFE PHOTOGRAPH, AGE FIFTEEN

*Red Fox - September 1961*

# ACKNOWLEDGEMENTS

My family is here with me again for another exhausting but rewarding endeavor. With hugs and an occasional sharp stick they do the difficult behind-the-scenes heavy lifting that is needed for a project like this to succeed. My wife, **Judy Brandenburg**, and daughter, **Heidi Brandenburg-Ross**, managed the countless day-to-day details that a distracted summer searcher like me required. **Anthony Brandenburg**, my son and graphic designer, touched this book with his magic wand. He also designed our highly acclaimed website. Indeed, this is no solitary journey.

My assistant and visual confidant, **Fanchon Lavigne**, was steadfast in her gentle guidance towards the elusive and impressionistic rather than a more tempting literal interpretation of my days' work. Elle m'a apporté un accent d'art de vivre.

**Nana Nishigaki** brought a keen eye and a sharp mind to my website and this book. 彼女は、私のこころの中にある日本をひきだしてくれた。

**Milli Bissonett**, **Diane Heep** and **Brett Ross** always lend a dignified and gracious voice to the images at the Brandenburg Gallery in Ely.

Animal lover **Bonnie Howe** not only keeps my space tidy and livable, but also alerts me to those nearly invisible wild creatures in the forest.

**John Echave**, the indefatigable Senior Editor at *National Geographic*, who, with *Chased by the Light* and now again with this summer's diary, unexpectedly brought my work back to the pages of my old home at *National Geographic Magazine*.

**Bryan Trandem**, my editor at Creative Publishing international, showed his usual stable and grounded persistence on this project. This book would not have happened without his professional dedication.

**Michael Furtman** assisted me with some last minute wordsmithing in the introduction. As always, he brings an uncommon empathy to my work.

**Tom Curley** and **Jennifer Davalos** from Fuji, and **Larry Opitz** from Nikon generously shared their latest digital cameras with me for this project.

**Randy Creeger** and **Dave Smith**, my childhood friends, convinced me to establish a non-profit Brandenburg Gallery in Luverne, Minnesota, which led the Brandenburg Prairie Foundation to save some of Rock County's last unbroken tall-grass prairie—to me, the most important work of all.

# A FRIENDSHIP IN CONSERVING LAND

Photography and land have always had a magical relationship. Since the dawning days of the art, photography has been one of the most influential tools for promoting land conservation. William Henry Jackson's pioneering images of the Yellowstone River's Grand Canyon directly resulted in the creation of America's first national park; and Ansel Adams' body of work delivered the majesty of our nation's landscapes into the minds of people everywhere. Once seen, those images could not be forgotten, nor the landscapes neglected. These early image-makers conveyed through camera lenses the transformative effect that land has on people.

This book is a continuation of that photographic heritage begun over a century ago. Behind these images is the personal story of a photographer who, so deeply moved by his subjects, has sought ways to protect these landscapes for others to enjoy. Jim Brandenburg's work has helped promote land conservation, including the continued protection of the Boundary Waters Canoe Area Wilderness that surrounds his home, Ravenwood, and the establishment of the Touch the Sky Prairie National Wildlife Refuge near his birthplace on the prairie of Minnesota.

But in the summer of 2002, Jim Brandenburg sought a way to make an even greater conservation impact. Though millions had seen his photographs of the land surrounding his Minnesota home, he worried that that land would not always be there for others to enjoy. To permanently conserve some of the land pictured in this book, Jim enlisted the help of a national conservation organization, the Trust for Public Land, because of its mission to protect land for people. What

began as a working relationship has grown into a friendship, and a key entry point to one of our most popular wilderness areas is now permanently protected as part of the Superior National Forest.

The relationship between people and the land is one of the most authentic and basic relationships in our modern world. It can call people to action and inspire them to create. The spirit of that relationship lives in Jim's photography. And the Trust for Public Land is inspired by that same authenticity each and every time we help a community create a new park, build a trail, or conserve a forest.

The author and the people of the Trust for Public Land hope that these images move you to seek and protect land that speaks to you, to discover your own personal Walden Pond, a place where the land is teacher and touches your soul.

You, reader, now own the images in this book and the land where these images reside. May you carry them both in your hearts and minds forever and accept the responsibility of keeping them sacred. May you also work to create more stories of conserving land for people.

Will Rogers
President

THE
TRUST
FOR
PUBLIC
LAND

Conserving Land
for People

*The Trust for Public Land conserves land for people to enjoy as parks, gardens, and natural lands, ensuring livable communities for generations to come.*

116 New Montgomery Street, Fourth Floor
San Francisco, CA 94105

(415) 495-4014 www.tpl.org

# ADDITIONAL INFORMATION

To order prints from this book or to view other Jim Brandenburg works and products, please call the Brandenburg Gallery toll-free at 877-493-8017 or visit us at *www.jimbrandenburg.com*. View the most complete collection of Jim Brandenburg's work at his northwoods Gallery in Ely, Minnesota, and at his prairie gallery in Luverne, Minnesota.

*CHASED BY THE LIGHT:* A Photographic Journey with Jim Brandenburg, DVD and VHS Video. Aired on Public Television, this award-winning documentary captures the original project that inspired *Looking for the Summer* through  beautiful imagery, music, and location interviews with Jim Brandenburg and his family. The hour-long program also includes a slide show narrated by Jim, featuring all 94 images of *Looking for the Summer* plus some outtakes not chosen for the project.

The Brandenburg Prairie Foundation was established in 1999 to "Educate, Promote, Preserve, and Expand Native Prairie in Southwestern Minnesota." Help us preserve and restore native prairie by becoming a member of the Brandenburg Prairie Foundation. Individual memberships start at $15. Members will receive Jim Brandenburg's "Dream Back the Bison" poster promoting the National Tallgrass Prairie Wildlife Refuge with a contribution of $50 or more.

For more information about the Brandenburg Prairie Foundation, please visit our web site at:

*www.jimbrandenburg.com/bpfoundation.html*
or write to us at:
*Ravenwood Studios/Brandenburg Prairie Foundation*
*14568 Moose Lake Road*
*Ely, MN 55731*

NorthWord Press, 18705 Lake Drive East
Chanhassen, MN 55317, 1-800-328-3895
Designed by Jim Brandenburg and Anthony Brandenburg

Library of Congress Cataloging-in-Publication Data

Brandenburg, Jim
    Looking for the summer / Jim Brandenburg
        p. cm.
    ISBN 1-55971-838-2 (retail edition)
    ISBN 1-55971-002-0 (limited gallery edition)
    1. Nature photography--Minnesota. 2. Brandenburg, Jim.  I. Title.

TR721.B75 2003
779'.3'09776--dc21                                              2003055117

First Edition
10 9 8 7 6 5 4 3 2 1
Printed in Singapore